Ian Dunlop

EDVARD MUNCH

With 40 color plates

ST. MARTIN'S PRESS NEW YORK

Published in the United States of America in 1977
by St. Martin's Press, Incorporated
175 Fifth Avenue, New York, N.Y. 10010

© Blacker Calmann Cooper Ltd, 1977
This book was designed and produced by Blacker Calmann
Cooper Limited, London

Library of Congress Catalog Card Number: 77–71078

ISBN 0–312–23822–3

Printed in Italy by Amilcare Pizzi S.p.A.

Introduction

THE BEST INTRODUCTION to the art of Edvard Munch is the artist's own words, written when he was twenty-six. It was New Year's Eve, a time when many assess their lives and express their hopes for the future. Munch was living at St Cloud on the outskirts of Paris. His father had died a month before, and he found himself brooding on the concerns which were to occupy him for most of his life: the nature of sexual attraction, the meaning of death, and how both could be related to his art. In his diary he wrote:

A strong bare arm, a sunburned, muscular neck – a young woman rests her head on his aching chest. She closes her eyes and listens with open, quivering lips to the words he whispers into her long flowing hair.

I would give form to this as I now see it, but envelop it in a blue haze. These two in that moment when they are no longer themselves but only one of thousands of links tying one generation to another generation. People should understand the sanctity of this moment and take off their hats as if they were in church.

I would make a number of such paintings.

Up to this point Munch had produced work with titles such as: *The Sick Child, Spring, Evening Hour, The Morning After.* They were based on scenes he had found and grown up with in his native Norway – his family, his friends, the streets of Christiania (now Oslo) and the landscape of the fjords. They were painted in a straightforward naturalistic style and although many of these early works convey a sad and melancholic note, the outstanding example being *The Sick Child* of 1885, Munch was aware that he had not penetrated to the inner, emotional significance of these scenes. It was not enough to paint 'people who only read and knit', the artist must go further and paint 'living people, breathing and feeling, suffering and loving.' 'Life and not lifeless nature', he wrote on another occasion.

Munch's grand ambition to paint 'feelings', his dissatisfaction with an art concerned mainly with the faithful portrayal of natural appearances, was shared by a number of artists at that time, notably Van Gogh and Gauguin. When he announced his intention to produce paintings 'designed to move people intensely, first a few, then more and more, and finally everyone,' he was expressing sentiments almost identical to those in Van Gogh's letters, written from Arles two years earlier. But these were not new sentiments. They hark back to the ideas put forward by many northern Romantics half a century earlier. The greatest of these artists, Caspar David Friedrich (1774–1840) had urged the painter to depict not only what he sees before him but also what he sees inside himself, to concentrate on his spiritual, and not just his physical, eye. Munch's significance, the source of his continuing appeal, is that he gave the Romantic tradition a new twist and a new subject matter, and in the process he became a link between the Romantics of the nineteenth century and the Expressionists of the twentieth.

The new subject matter was largely sexual in character. Whereas Romantics like Friedrich and Turner had aroused a feeling of awe by depicting man's insignificance in contrast to the vastness and majesty of nature, Munch depicted man's helplessness in face of overwhelming sexual force. He replaced the romantic sense of awe, with its religious implications, with the modern

world's sense of anxiety, particularly sexual anxiety. His figures seem entrapped in a cycle of sexual longing, destructive passion, jealousy and death. The terrors of the Romantics, those avalanches, torrents, fires and impenetrable mists, are replaced by the fears brought on by introspection, a kind of vertigo. Years later, he himself admitted that many of his ideas show remarkable parallels to Kierkegaard's writings. As early as 1894 his friend the poet, Stanislaw Przybyszewski, recognized Munch's significance and greatness: 'Everything which is dark and deep, all that for which language has not yet found any words, and which expresses itself solely as a dark and foreboding instinct, all these take on colour through him and enter our consciousness.'

Munch's imagination was largely shaped by his childhood experiences. He was born in 1863, the son of a doctor who had a practice in the poorer parts of Christiania. When he was five his mother died, a traumatic event for any child, but it was made worse by the effect it had on his father, who, according to Munch, 'had a difficult temper, and had inherited nervousness with periods of religious anxiety which could reach the borders of insanity as he paced back and forth in his room praying to God. . . . I felt always I was treated in an unjust way, without a mother, sick, and threatened punishment in Hell hanging over my head.'

His childhood was probably not as unhappy as all that. His mother's place was taken over by her sister, Karen Bjolstad, who proved a sympathetic support to him in his artistic career, becoming the main recipient for his letters home. But, as a child, sickness and death were never far away. Munch himself suffered from tuberculosis and nearly died. Then when he was fourteen, his favourite sister Sophie died of the same disease.

Understandably these terrible experiences made a deep impression and they became the inspiration for many of his most powerful canvases – *The Sick Child*, already mentioned, and *The Chamber of Death* of about 1892.

Munch's own illness indirectly fostered his career as an artist. His frequent absence from school ruled out any plans his father had for a career in engineering and he was allowed to study painting, first in the state school and later in the studio of Christian Krohg.

Krohg introduced him to naturalism and exerted a behind-the-scenes influence on his early work. The composition of *The Sick Child*, for example, echoes Krohg's *Sleeping Family* of 1883, a resemblance overlooked in most studies on Munch.

Krohg also introduced Munch to a world far removed from the confines of his family – the Bohemians of Christiania, a small group of anarchists and radicals who shocked and scandalized the placid middle-class society of the Norwegian capital in the 1880s. Krohg was a member of this group and his Zolaesque novel, *Albertine*, which told the story of a prostitute, was published in 1886, and promptly confiscated for indecency. A year earlier the same fate had befallen the leader of the Christiania Bohemians, Hans Jaeger, whose account of his life and loves, in which sexual matters were aired with undreamt of frankness, led to his arrest and imprisonment. Jaeger came to exert a considerable influence on the young Munch, much to his father's annoyance. His portrait is one of Munch's finest works of the 1880s.

The ideas which stirred the Christiania Bohemians, the clamour for sexual freedom, now seem commonplace, indeed a cliché of Scandinavian life. But in Munch's youth they were the subject of fierce debate. Christiania was then a small backward provincial city. It had a population of about forty thousand, of which half were under the age of twenty-three. It had few buildings of note, its amenities lagged behind those of the rest of Europe; it possessed no great

museum of pictures, culturally it remained dependent on Denmark and Germany, and socially it was dominated by the middle class. It did possess one fine street, the Karl Johan Street, which features in many of Munch's most attractive canvases. In the summer months, weather permitting, Christiania society would promenade along it and listen to the brass bands. It possessed also one great dramatic genius, Ibsen, who had begun to explore the moral, social and sexual conflicts that lay hidden beneath the comfortable facade of Norwegian society.

Munch's friends, impatient for change, took a more extreme position. 'Free love' was their clarion call. It was against this background and these debates that Munch was to discover for himself the reality of sexual freedom.

Although tall and good-looking, he was shy and distrustful of the opposite sex. His first experience of love seems to have left a permanently unhappy mark. The initiation seems to have been brought about by the wife of a naval medical officer, called 'Fru Heiberg' in his diaries. She was three years older than Munch, she had no children, and she felt free to do as she liked. 'Her determination to retain her free will in everything,' as he put it, exasperated him and drove him to wild fits of jealousy and suspicion. The affair lasted on and off for six years and the wounds never quite healed. 'What a deep mark she has left in my heart,' he wrote in his Paris notebook. 'No other picture can ever totally replace hers. Is it because she was beautiful? No, I'm not even sure she was pretty; her mouth was big. She could even be repulsive . . . Is it because she took my first kiss and took from me the perfume of life?'

Munch's own personal experience of the destructive forces of love was reinforced by many northern writers at that time. The idea of woman as a destroyer of man's creativity, as a devouring monster driven by an overwhelming urge to procreate, can be found in the plays of Ibsen (*Hedda Gabler* was produced in 1890) and those of Munch's friend, August Strindberg.

It was then partly as a result of his own experience and partly in keeping with the ideas of his time that Munch came to create those unforgettable images of love, passion and jealousy, which together with death, became the recurring theme of his art in the great paintings of the 1890s.

The means for realizing these ideas came as a result of his studies in Paris which lasted about two and a half years, beginning in 1889. As with another northern artist, Van Gogh, who had arrived in Paris three years earlier, the contact with advanced French painting had a liberating effect, opening up new possibilities in the use of colour and the handling of paint. Both artists tackled typical Parisian subjects in the manner of the Impressionists and the Pointillists, but in both cases the style is on the surface only and the bones of their northern temperament can be seen jutting through.

Unlike Van Gogh Munch does not seem to have made much effort to get to know the leading French artists of the time. He preferred the company of other Scandinavians, and his letters home reveal little about his artistic tastes. Did he notice the Van Goghs in the Salon des Indépendants of 1891? Was he aware of Gauguin and his aesthetic theories? What was his reaction to the Pointillists led by Seurat? Did some of the titles of his paintings indicate a knowledge of Whistler? These questions have troubled art historians and will continue to do so for some time to come. But one thing is certain. By 1892, when he left Paris, Munch had emerged as a mature artist, capable of producing dramatic works like the portrait of his sister Inger, capable of arousing a sense of disquiet in paintings like *The Yellow Boat*; Munch had in fact opened up a vast gulf between himself and other Norwegian artists. His old teacher, Krohg, attending the exhibition of his pupil's work in Christiania

in the late summer, noticed the difference and drew attention to the new resonance in Munch's colours.

Although the exhibition did little to win over his countrymen, who, with few exceptions remained hostile to his work, it did lead to two important consequences affecting his art and his career. First, seeing his paintings hung together, Munch was struck by something like a musical tone running through them. The possibility of painting a series of works in which a theme could be explored now occurred to him, and the following year he embarked on a cycle which he called Love and which became part of the *Frieze of Life*.

Secondly, the exhibition led to an invitation to show his work with a union of Berlin artists. The exhibition opened on 5th November 1892, and Munch's work gave rise to a memorable furore. After a week he was asked to remove his 'schmieren' (daubs), despite the protests of a minority of the union who, under the leadership of Max Liebermann, left to form their own society, the Berlin Secession.

Munch seems to have enjoyed the rumpus. The resulting publicity brought him to the attention of German critics, dealers and collectors, inspired further exhibitions of his work and encouraged him to make Berlin the base of his operations. Munch now found himself part of a Bohemia that was more wild, dissolute and sophisticated than anything he had experienced in Norway. His circle included August Strindberg, the poet Stanislaw Przybyszewski (the model for *Jealousy*), his Norwegian wife, Dagny Juell, the critic Meier-Graefe and others. Their meeting place was the Zum Schwarzen Ferkel (The Black Pig) and Przybyszewski's rooms in north Berlin, where under a red paraffin lamp, Strindberg and Munch would take turns dancing with Dagny, who enchanted them both.

The Berlin Bohemia took a heavy toll on the emotional and physical state of its participants. Munch drank more and more, and his highly charged state at that time can be glimpsed in the *Self-Portrait with Cigarette* of 1895. Like the American abstract expressionists, who also made their own emotions the inspiration for their work, Munch found it hard to maintain his creative drive. In the course of a long career he produced a number of sloppy works and some outright failures.

Emotion was one thing, but finding the right form to express these feelings was not easy. However, once revealed they were difficult to dislodge and Munch returned to the same image, painting it over and over again. 'Art is crystallization' he maintained. In 1895 he began making prints; this enabled him to repeat and refine his images and themes still further. The techniques involved seemed to give him fresh inspiration. He started by making etchings, then in Paris in 1896, working with the master-printer Auguste Clot, who had supervised the prints of Toulouse-Lautrec, Bonnard and Vuillard, Munch turned to lithography, producing such haunting works as the colour lithograph of *The Sick Child*. Finally he turned to making woodcuts, and in this almost lost art form he showed amazing ingenuity.

The print provided a more intimate platform for his work, and in the opinion of many, his lithographs and woodcuts are more satisfying than his oil paintings. Certainly they greatly helped to spread his fame, and since the majority of his major oils are in Norway it was through his prints that his reputation reached the outside world. They also helped establish a market for his work, and from 1898 his critical standing grew, new patrons appeared and his finances improved.

But personal problems remained. He drank too much, he began to show marked schizophrenic tendencies and he became suspicious and unruly. Like Van Gogh in Arles he quarrelled with his friends. In 1895 he beat up the

painter Ludvig Karsten, whose portrait he had just finished. There were other brawls and in Copenhagen he was once arrested for fighting in a café. His increasing instability was fuelled by a disastrous affair with the daughter of a Norwegian business man, Tulla Larsen. She was determined to marry him, despite Munch's belief that on genetic grounds marriage for him was out of the question. She pursued him relentlessly, staging with the help of some friends a mock death-bed scene to which Munch was lured one stormy night. On another occasion she threatened to shoot herself, and in the resulting struggle accidentally shot off the joint of the third finger of Munch's right hand, by tradition in Norway the wedding finger.

This and other incidents seemed to have driven Munch into exile from Norway. At the suggestion of Count Harry Kessler (who seems to have known every artist and writer in Europe at that time) he sought refuge in Weimar in Germany. But he became restless, the drinking continued, and the various cures he tried had little effect. Finally, in Copenhagen in 1908, after a four-day drinking spree, he turned himself over to the care of the psychiatrist, Dr Daniel Jacobson. For the next eight months he underwent a series of treatments, including electric shocks, and he emerged, if not healed in his mind, at least cured of his alcoholism. In 1909, urged by his Norwegian friends, he began his return to Norway, where apart from occasional trips abroad, he was to remain for the rest of his life, living alone, avoiding people, even his family, and painting.

Public recognition of his art in Norway was now assured. The National Gallery of Oslo, under the direction of his friend, Jens Thiis, had already begun to build up the collection of his work for which it is famous. In 1911, Munch won the competition to decorate the recently built auditorium at the University of Oslo. This was the kind of project he had been waiting for. But the results were disappointing with the exception of one panel: the powerful image of the sun rising over the sea, radiating energy and light.

Over the next thirty years Munch produced a great quantity of work, landscapes, self-portraits, repeats of earlier themes and some new subjects such as workers shovelling snow and returning home from work. But although these paintings deal with incidents in his life, for example his fight with Karsten and an attack of Spanish 'flu, they do not reveal his inner feelings. Perhaps his breakdown had made him reluctant to examine once again the anxieties which had inspired the great pictures of the 1890s. Evidently the fears were still there; in his seventies he told his physician, 'the last part of my life has been an effort to stand up. My path has always been along an abyss.'

Munch died on 23rd January 1944, a month after his eightieth birthday. In his will he left all his work to the city of Oslo: 1,008 paintings; 15,391 prints; 4,443 drawings and watercolours; and six sculptures. Unfortunately after thirty years a complete catalogue of his works has not been produced and his extensive letters and diaries are only available in Norwegian. He died a lonely man, all his family having predeceased him. Much still remains to be discovered about Norway's greatest artist, who appeals to an ever increasing audience, thus fulfilling his ambition to move 'first a few, then more and more, and finally everyone.'

1. *The Sick Bay*

1882. Oil on canvas. 26½ × 23in (67·3 × 58·4cm)

This work, painted when Munch was eighteen, recalls an excursion with his father to a field hospital. It is rendered in the naturalistic manner which he had learnt in the studio of Christian Krohg, but the pensive expression of the soldier with his feet on the bed, his isolation from the sick figure attended by the nurse, already conveys the feeling for psychology which is such a feature of his subsequent work.

Oslo, Munch Museum

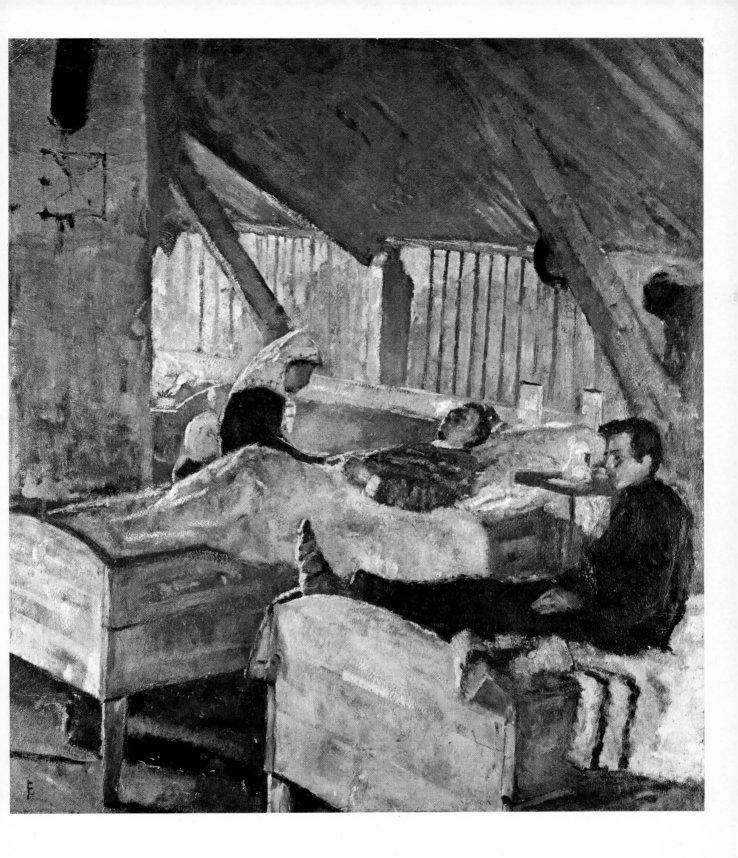

2. *The Sick Child*

1885–6. Oil on canvas. 47 × 46¾in (119·4 × 119cm)

The death of his sister Sophie made a deep impression on the young Munch. It was one of those scenes which he could never erase from his memory and he went on to portray it six times in oils and twice in prints. The first of the oils was begun in 1885 when he was twenty-three. He worked on it for nearly a year and in the process he transformed a painting which had started out as a naturalistic description of the sick room, full of anecdotal detail, into a work of considerable intensity.

The painting was attacked vehemently when he exhibited it. People objected to the crude surface of the painting which had been scarred by scratches made with the back of his brush (a technique perhaps suggested by the Rembrandts Munch had seen for the first time the previous year). But Munch was not dismayed. 'With *The Sick Child*,' he wrote later, 'I opened up new paths for myself. It became a breakthrough in my art. Most of my later works owe their existence to this picture.'

Oslo, National Gallery

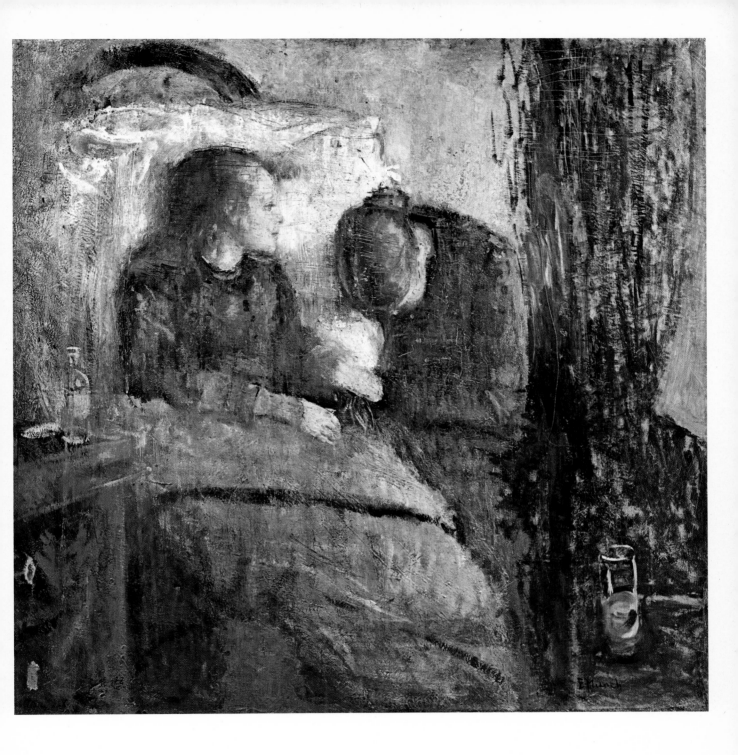

3. Spring

1889. Oil on canvas. $66\frac{1}{2} \times 103\frac{7}{8}$in $(169 \times 263 \cdot 7cm)$

Spring is a large canvas, over five feet by eight, presumably intended as an answer to the critics of *The Sick Child*, and also perhaps painted with an eye on a scholarship which was to take him to Paris later that year. It repeats many of the motifs of the earlier work but in a more acceptable manner and with a greater sense of realism. There are the same two figures, the glass and water jug, and the pallor of the sick girl is again emphasized by the effect of her head against a white pillow. But, despite the title, the mood is more despairing. The girl turns away from the light, from spring billowing in through the curtains, in apparent resignation to her imminent death.

Oslo, National Gallery

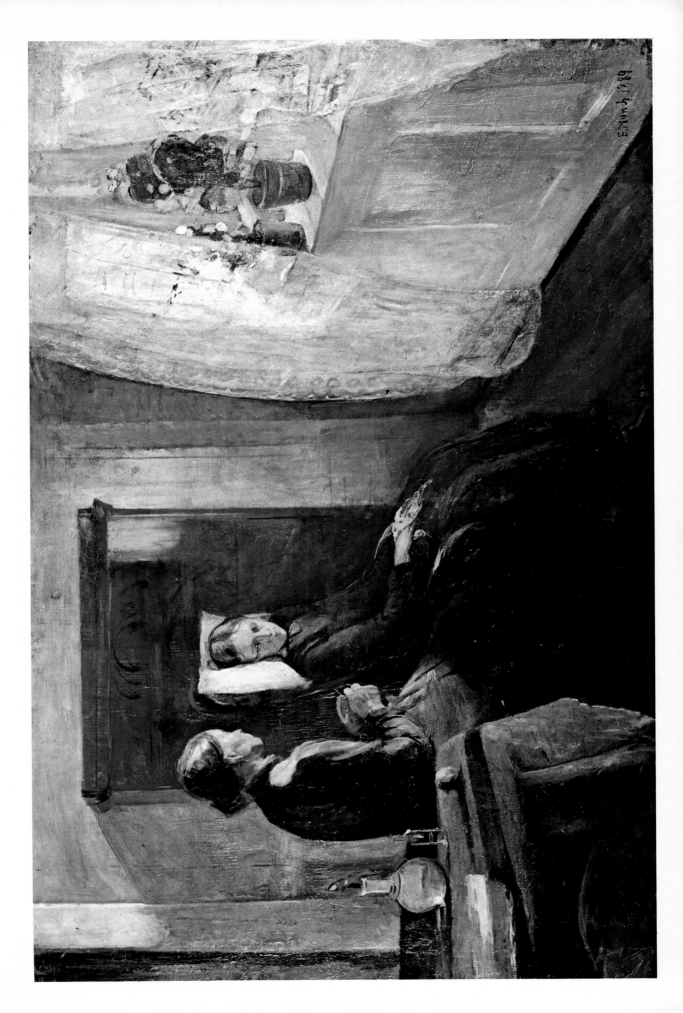

4. *The Evening Chat*

1889. Oil on canvas. $59\frac{1}{8} \times 76\frac{3}{4}$in ($150 \times 195$cm)

Using his sister Inger and the poet Bodtker for models Munch set out to paint a conversation piece in which there is a notable lack of conversation. It catches two people in a strange and silent colloquy in which feelings of sexual attraction are sensed rather than stated. In this work the figures are shown out of doors, not far from the seashore – a favourite setting for many of his works which deal with attraction between man and woman (*see plates 17 and 34*). Munch endeavoured to use landscape to reflect the internal psychological state of the people in his pictorial dramas.

Copenhagen, The Royal Museum of Fine Arts

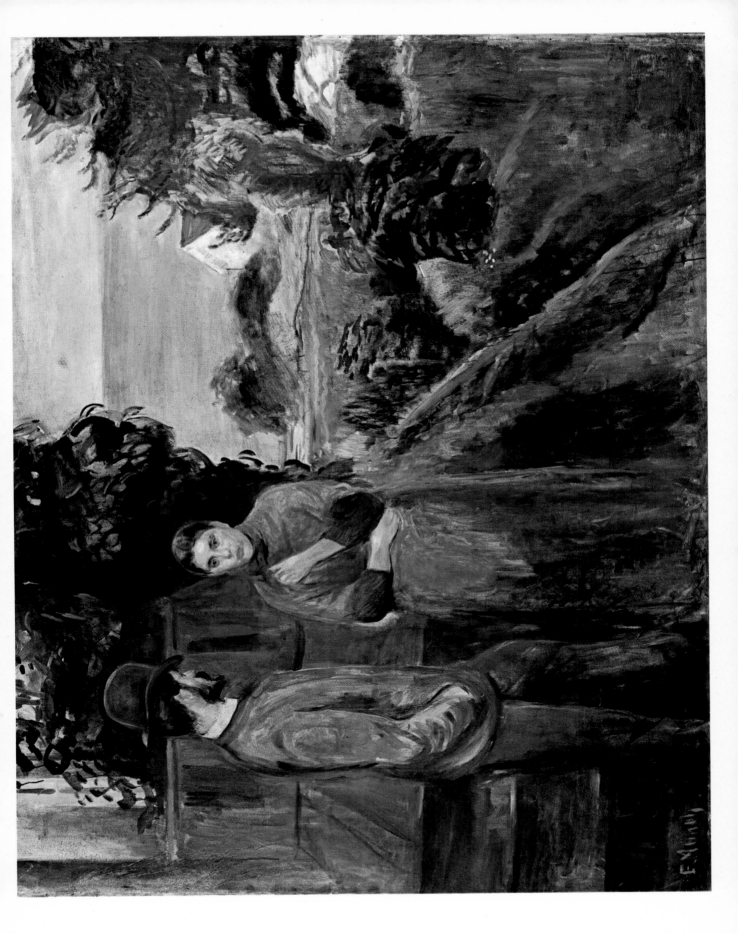

5. *Military Band on Karl Johan Street, Oslo*

1889. Oil on canvas. $40\frac{1}{8} \times 55\frac{3}{4}$in ($102 \times 141{\cdot}6$cm)

The Karl Johan Street, is the main thoroughfare in Oslo connecting the castle with the city centre. It was also the main meeting place for the Oslo middle classes who enjoyed a daily promenade during the spring and summer months. 'When a military band came down Karl Johan Street one sunlit spring day', Munch recalled 'my mind was filled with festival – spring – light – music – till it became a trembling joy – the music painted the colours. I made the colours vibrate to the rhythm of the music. . . .' Indeed it is almost possible to hear the clash of brass in the contrast between the red parasol and the solid blacks in the figures on the right of the picture.

Zurich, Kunsthaus

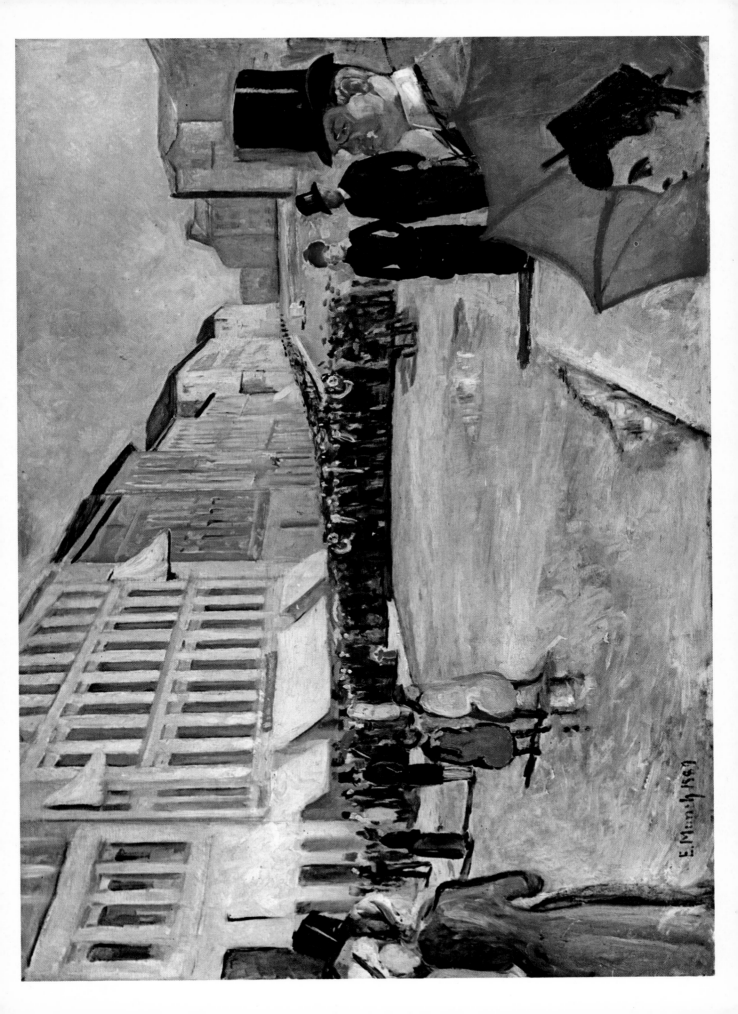

6. *The Morning After*

repainted c.1893. Oil on canvas. $45\frac{1}{4} \times 60$in ($115 \times 152 \cdot 4$cm)

The first version of this work (later destroyed in a fire) was begun around 1885 at a time when Munch spent a great deal of his time with his Bohemian friends in Christiania. This slice-of-life subject, which might have served as an illustration to a Zola novel, tells an obvious story: a woman, her loosened bodice stained with wine, lies exhausted on a bed. Empty bottles and glasses are on a table just out of reach. To the middle classes of Christiania the subject would have been deeply shocking, as much an affront to public morals as Hans Jaeger's writings.

Oslo, National Gallery

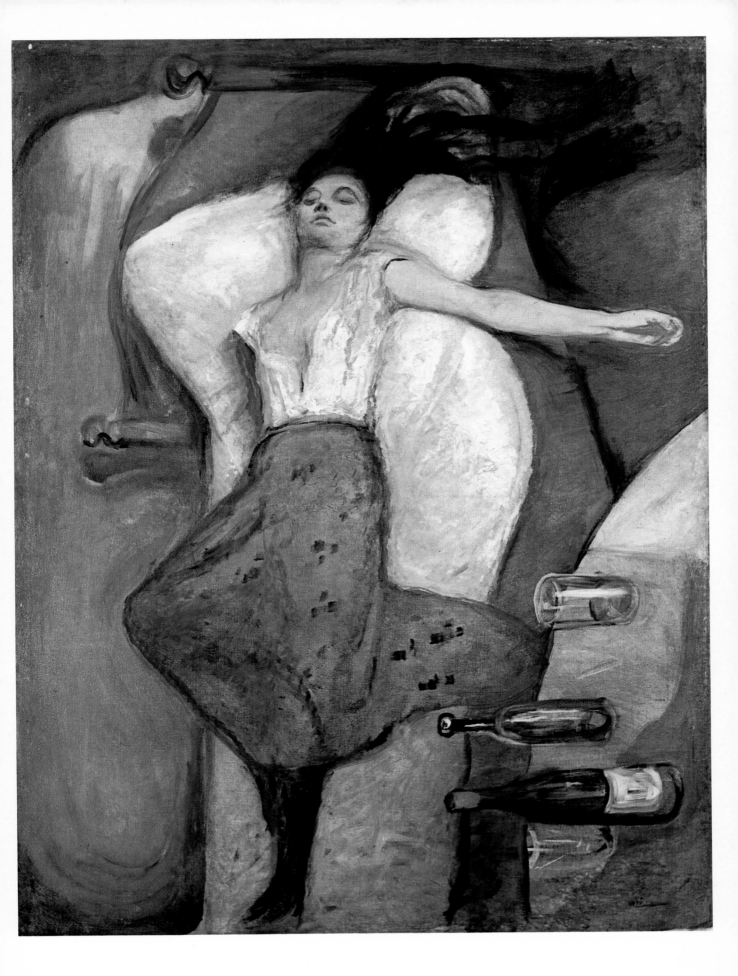

7. *Hans Jaeger*

1889. Oil on canvas. 43 × 33⅓in (109·2 × 84·3cm)

Hans Jaeger was the leader of the Christiania Bohemians. His attacks on Christianity and sexual repression made him a notorious figure in Norway at that time. He came to exert a strong influence on Munch as a young man. He is seen in this sensitive portrait as a shabbily dressed character with a quizzical expression.

Oslo, National Gallery

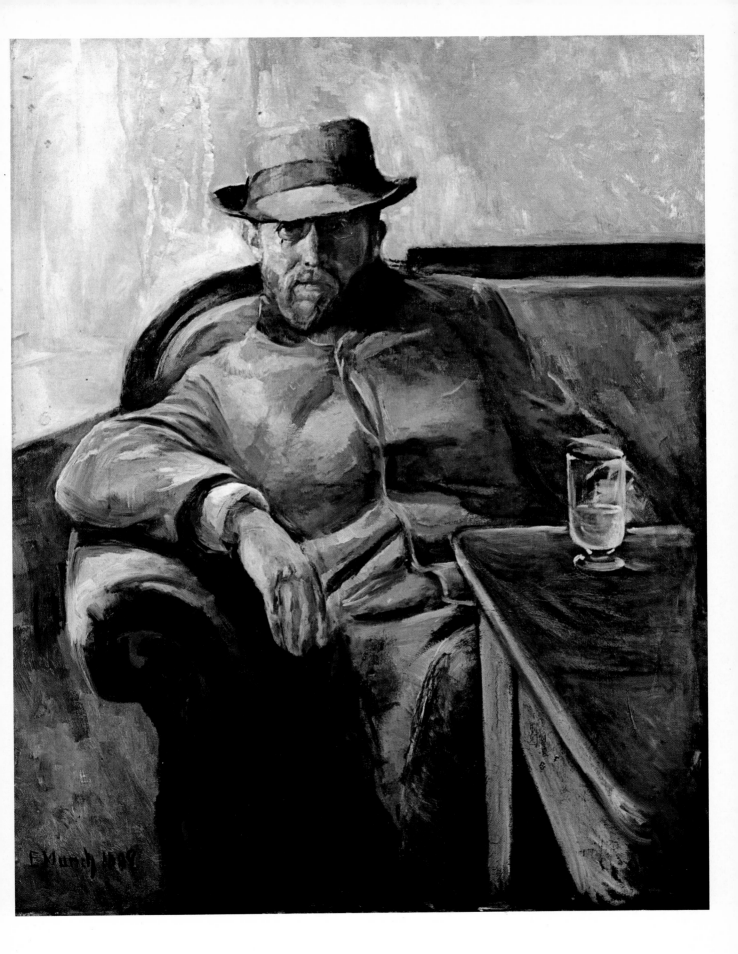

8. *Puberty*

repainted c.1893. Oil on canvas. $59\frac{1}{2} \times 43\frac{1}{4}$in $(151 \cdot 2 \times 101cm)$

The motif of a girl or woman sitting on the edge of a bed is one which Munch repeated many times in his career. This painting is a repeat of an earlier version also destroyed in a fire. It is hard to say how close it is to the original. The dramatic device of the shadow cast by the girl on the wall behind her, suggesting some brooding presence or alter-ego, is probably an image which Munch developed after his move to Paris in 1889 and was not in the original work. Interestingly, it is a device which also appealed to Gauguin.

Oslo, National Gallery

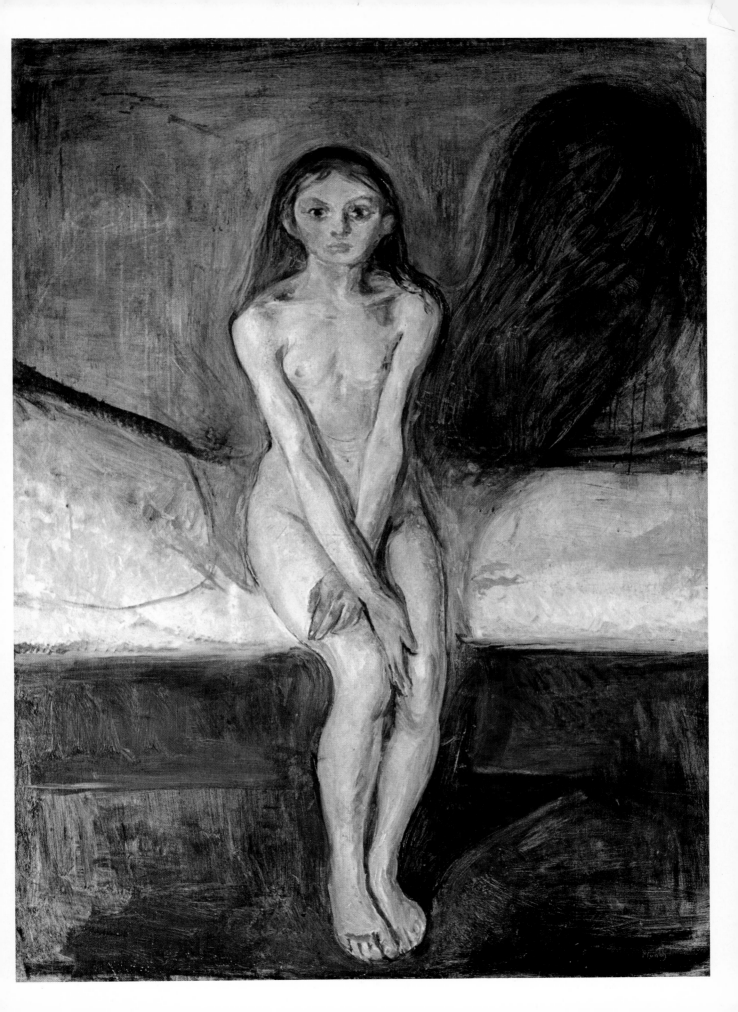

9. *Rue Lafayette*

1891. Oil on canvas. $36\frac{1}{4} \times 28\frac{3}{4}$in (92·1 × 73cm)

Over a decade earlier the Impressionists had painted
Parisian street-life seen in blurred confusion from a high
vantage point. Monet's *Boulevarde des Capucines*, and
paintings by Pissarro and Caillebotte are obvious
forerunners to this painting of the rue Lafayette, completed
before Munch's return to Norway in May, 1889. There is
also a strong suggestion of Seurat in the dabs and dashes
of the brushwork. But the acute angle of the balcony
conveys a sense of unrest far removed from the calm static
compositions of Seurat at that time. With the benefit of
hindsight, this device seems to anticipate the acute
perspective found in *The Scream (plate 21)* and *Girls on the
Jetty (plate 31)*. In all three works figures are shown resting
on a railing as if recovering from an attack of dizziness.

Oslo, National Gallery

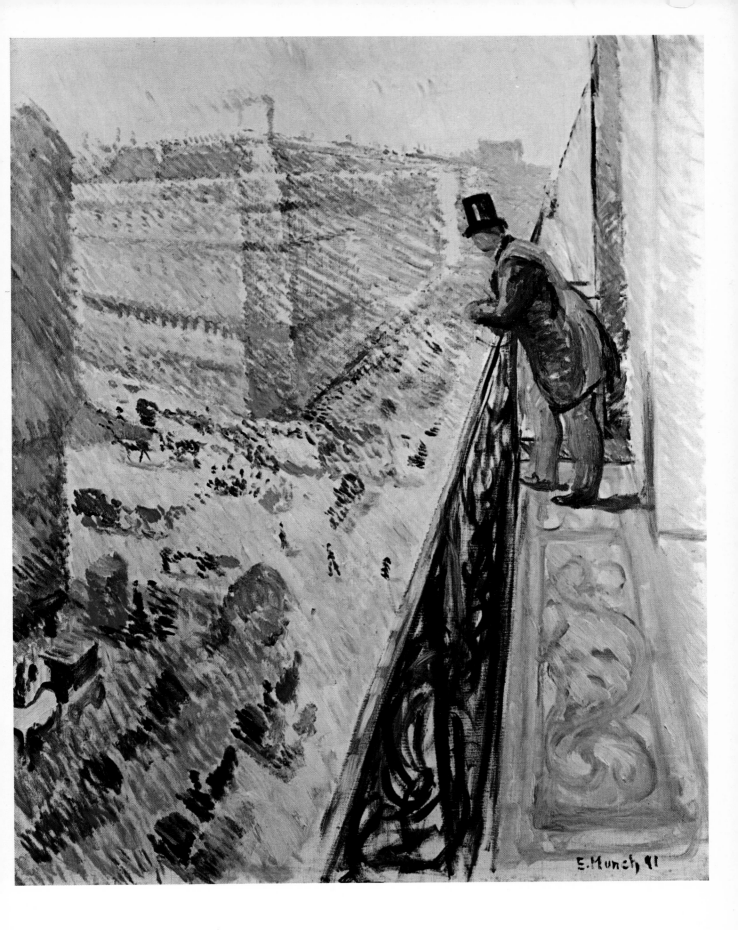

10. *Evening in Saint-Cloud*

1890. Oil on canvas. $25\frac{1}{2} \times 21\frac{1}{4}$in ($64\cdot8 \times 53\cdot8$cm)

Munch moved to Saint-Cloud on the outskirts of Paris at the end of 1889. It was there he learnt of his father's death at home in Norway and it was there he wrote the manifesto-like remarks quoted in the Introduction. The lonely pensive figure at the window, modelled after a Danish poet, captures his mood at that time. The subject matter and the tonal range of this work are reminiscent of Whistler's river views.

Oslo, National Gallery

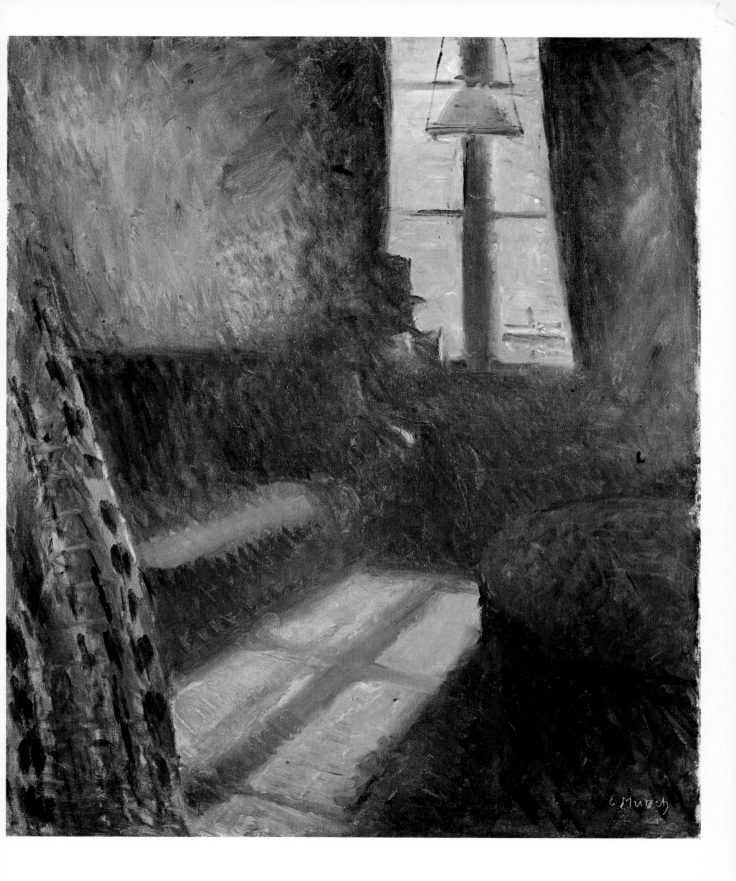

11. *Spring Day on Karl Johan Street*

1891. Oil on canvas. $31\frac{1}{2} \times 39\frac{1}{2}$in ($80 \times 100 \cdot 3cm$)

Like Van Gogh, Munch's contact with advanced French painting seems to have had a liberating effect. Munch was quick to absorb the lessons picked up from Seurat and others. But he seems to have been only trying out this style; soon he abandoned the bright colours and broken brushwork for a sombre and linear style, more in keeping with his northern temperament.

Bergen, Billedgalleri

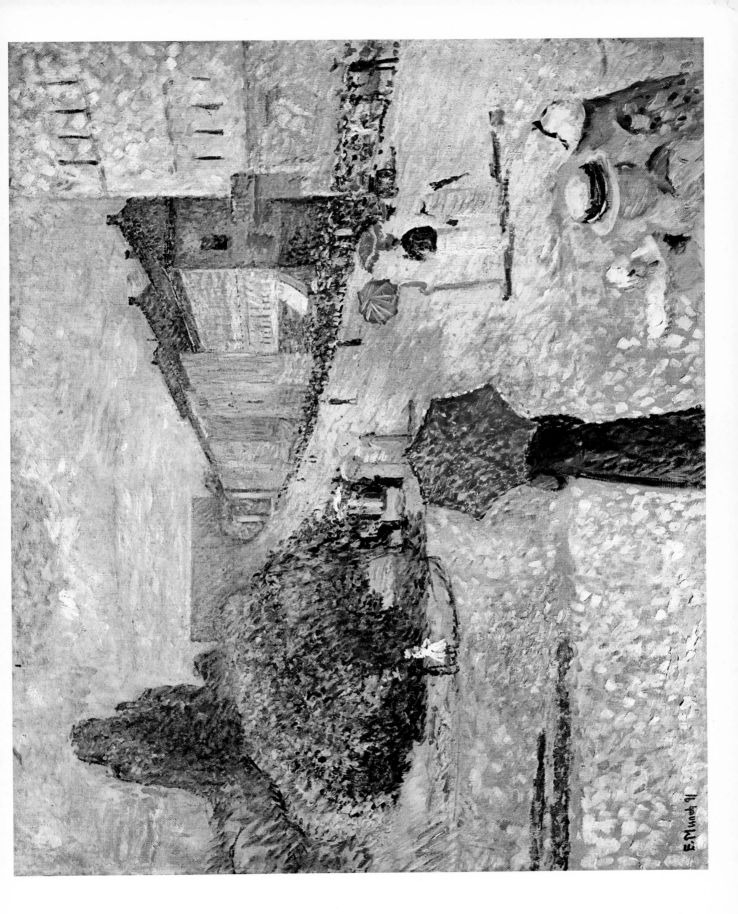

12. *Inger Munch*

1892. Oil on canvas. $67\frac{3}{4} \times 48\frac{1}{4}$in (192 × 122·6cm)

This strong portrait is the work of a confident and mature artist. It was painted within a year of the previous painting but the difference in technique is remarkable. The broken dabs of complementary colour have been replaced by a careful arrangement of tones, with thin liquid paint applied in loose brushstrokes to form broad areas of flat colour. This is the style which stamps the great paintings of the next few years. With this portrait, as his former teacher Krohg realized, Munch opened up a wide gulf between his work and that of his fellow Norwegian artists.

Oslo, National Gallery

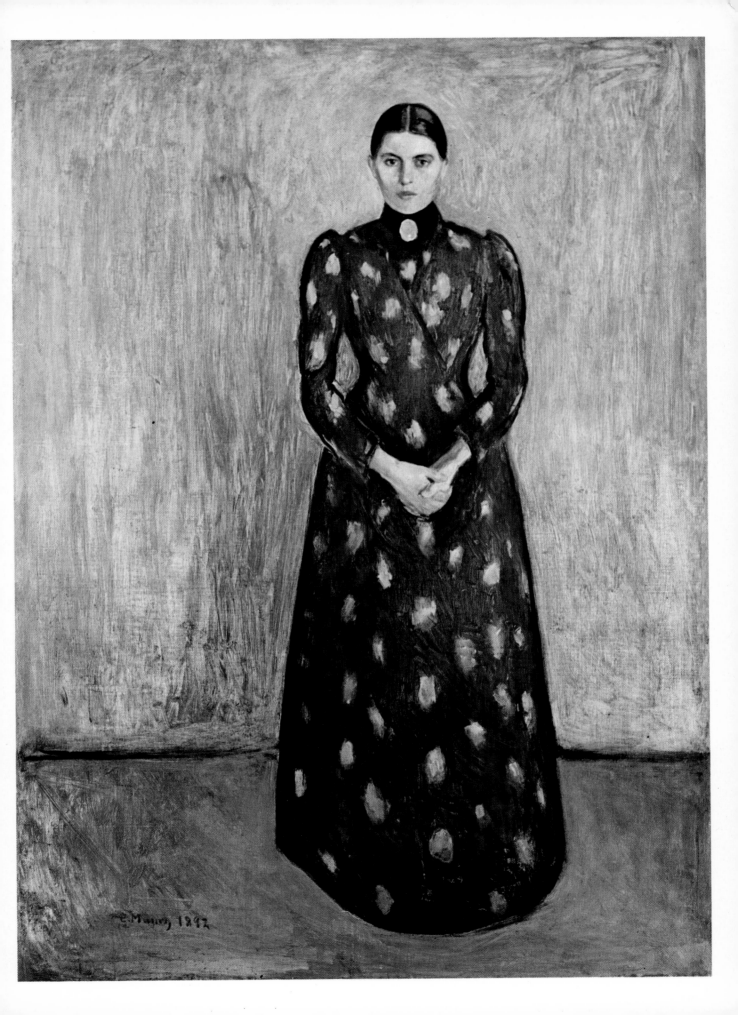

13. *Kiss by the Window*

1892. Oil on canvas. $28\frac{1}{2} \times 35\frac{3}{4}$in ($72\cdot4 \times 90\cdot8cm$)

The image of a couple embracing in a darkened room
beside a window was one which Munch repeated many
times in oils and perfected in woodcuts and engravings. It
is not a suggestive or erotic image, rather it is a pictorial
rendering of Munch's belief that sex involves a loss of
identity, depicted here by the fusion of the two faces. The
lips of the man and woman cannot be seen: instead, as the
poet Przybyszewski noted, we see only 'a giant ear gone
deaf in the ecstasy of blood. It looks like a puddle of melted
flesh.'

Oslo, National Gallery

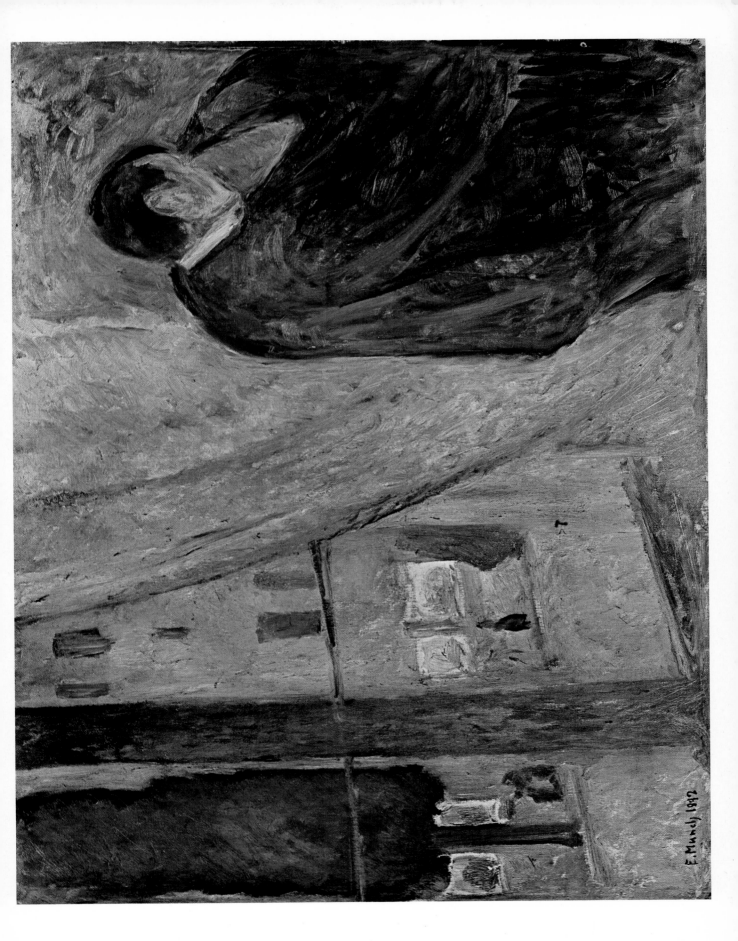

14. *Evening (The Yellow Boat)*

c.1891–3. Oil on canvas. 25½ × 37¾in (64·8 × 95·9cm)

The shores of the fjord at Asgaardstrand, where Munch spent his summer months with his Christiania friends, provided the setting for this painting, which also bears the title *Jealousy*. In the background a man and a woman stand on a pier, apparently about to embark on a small boat (a symbol, many Freudians would argue, for sexual adventure). In the foreground a brooding figure turns his back to the landscape and the event taking place. The emphasis on outlines, on flattened shapes, on meandering curves, no doubt derive from Gauguin's paintings at that time. But the use of greys and blacks to convey the psychological impact of the scene is characteristic of Munch alone.

Oslo, National Gallery

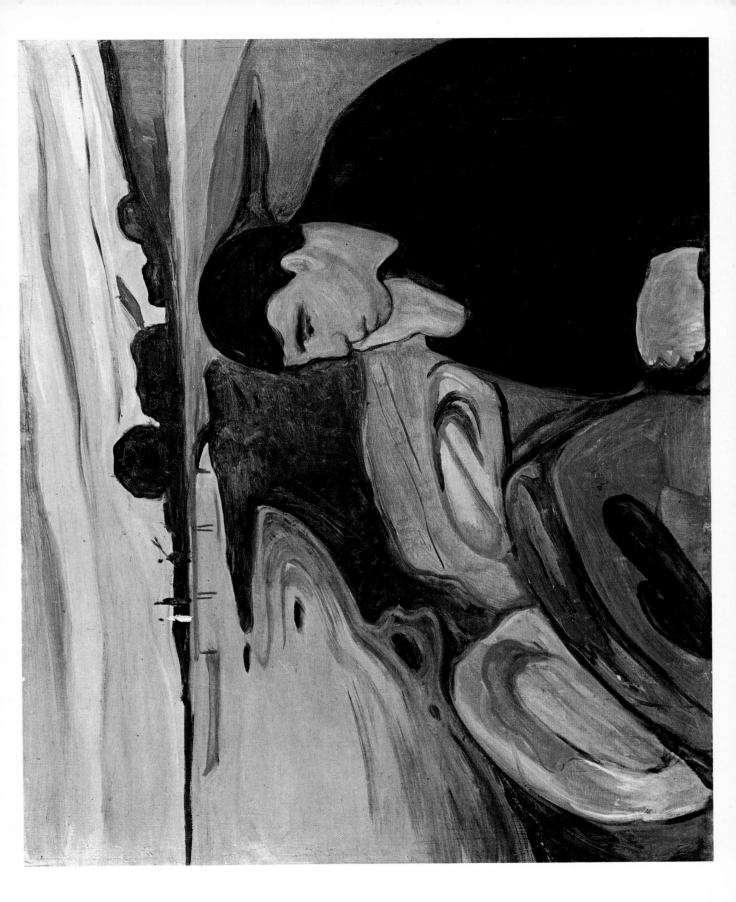

15. *Chamber of Death*

c.1892. Oil on canvas. 59 × 66in (149·8 × 167·6cm)

In this work Munch came closest to fulfilling his ambition to produce paintings which would make people feel 'the sanctity of this moment and take off their hats as if they were in church.' With no prior knowledge of the title the spectator would be aware that something terrifying and tragic had happened. But unlike *The Sick Child* in which attention is drawn to the fate of the invalid herself, in this painting attention is drawn to the effect of death on the living. Each family member is depicted in isolation from the others; each reacts in an individual way to the tragedy taking place. Munch's sister Inger stands in a similar position to the one in her portrait (*Plate 12*) and wears the same dress, but her expression is tense and pale and her eyes are bloodshot with tears. Munch's father stands beside the bed, his hands clasped in prayer. Munch himself hides his emotions. He stands behind his sister Inger, his face turned away from the spectator and from the death bed.

Oslo, National Gallery

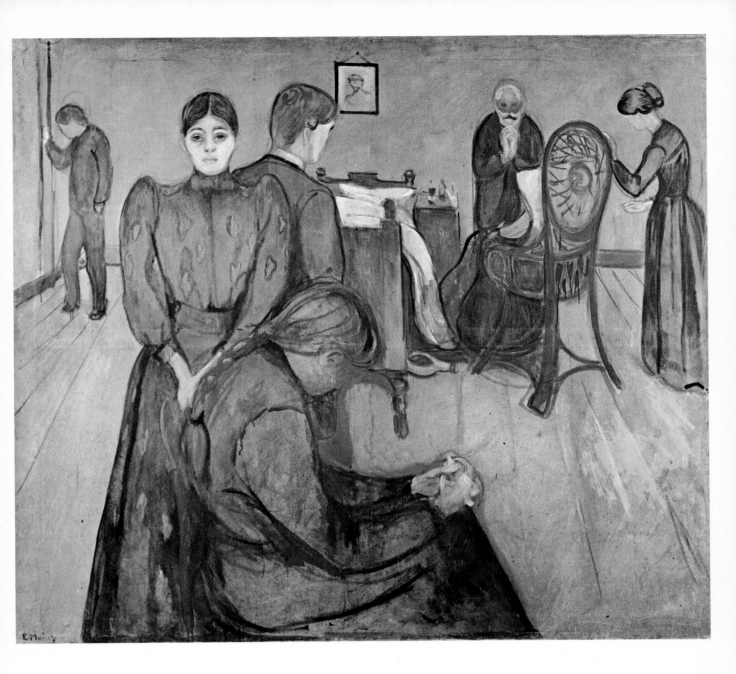

16. *Evening on Karl Johan Street*

c.1892. Oil on canvas. $33\frac{1}{4} \times 47\frac{5}{8}$ in ($84 \cdot 5 \times 121$ cm)

Munch was among the first artists of the late nineteenth century (the Belgian painter Ensor was another) to dramatize the menace of urban life and the loneliness people can feel in a crowd. The mood of the artist, represented here by the solitary figure in black with a top hat walking in the opposite direction to the flow of the crowd, transforms the gay carefree figures of plates 5 and 11 into grim, wide-eyed, walking skeletons.

Bergen, Collection Rasmus Meyers

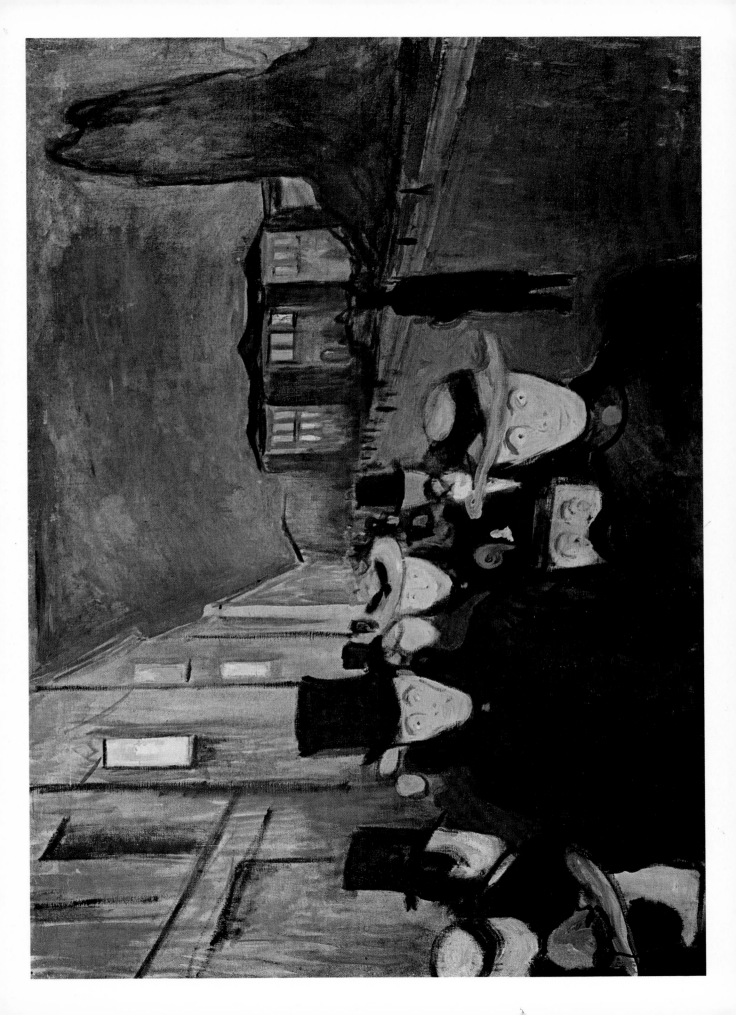

17. *The Voice*

1893. Oil on canvas. $34\frac{5}{8} \times 43\frac{1}{4}$in ($87 \cdot 9 \times 109 \cdot 9$cm)

The Voice is the first in a series of paintings about love
which Munch intended to form a section of a larger
scheme or cycle which he called the *Frieze of Life*. It depicts
a young girl's awakening to sexual desire. While the
midnight sun of the Norwegian summer turns, the virgin
girl dressed in white roves through the trees by the water's
edge. She invites seduction by lifting up her face and
forcing forward her breasts but she is still sufficiently timid
to keep her arms and hands clasped rigidly behind her
back. She both longs for and fears her first embrace.

Boston, Museum of Fine Arts

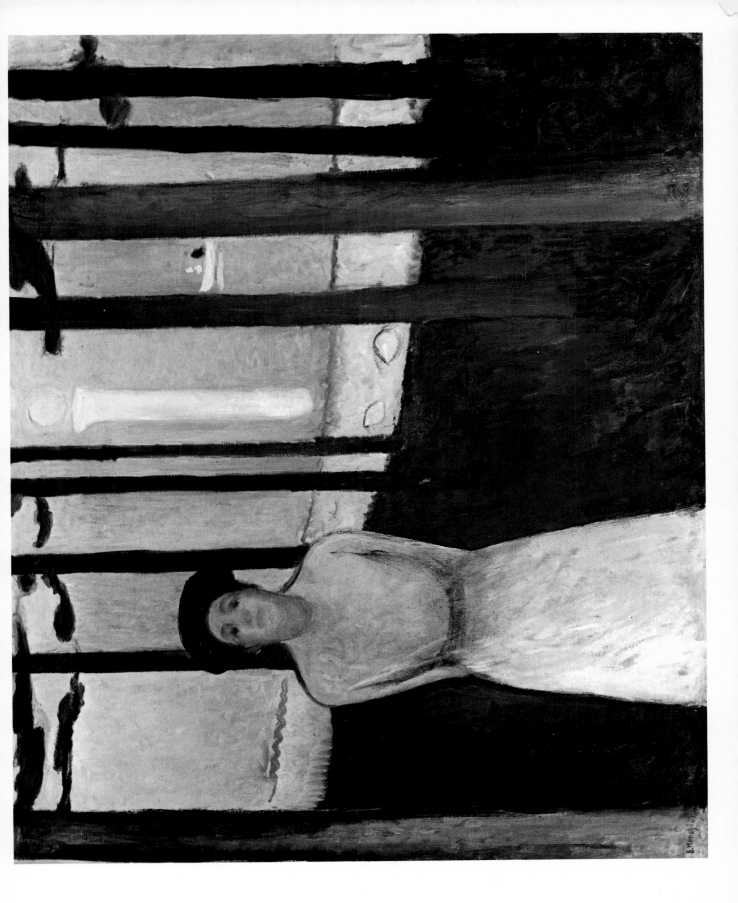

18. *Madonna*

1895–1902. Coloured lithograph. $23\frac{7}{8} \times 17\frac{1}{2}in$ (60·6 × 44·5cm)

The oil version of this lithograph was painted in 1893 and shows a later stage in the series on love. It depicts a woman at the moment of orgasm, wearing, as the artist described it, 'a corpse's smile', by which he meant that the moment of her fulfilment was also the moment of death. Having achieved her biological role of conception, 'the chain binding the thousands of dead generations to the thousands of generations to come is linked together.' In the lithograph this chain is represented by the flow of spermatozoa in the border and the shrivelled embryo which seems poised between life and death in the lower left hand corner.

Oslo, Munch Museum

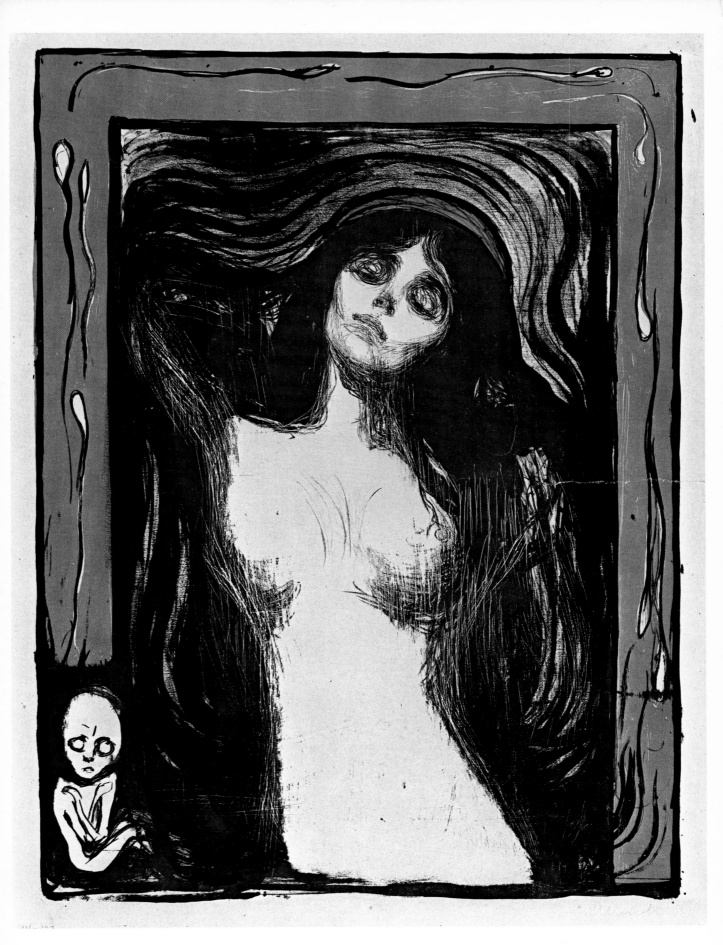

19. *Moonlight*

c.1893. Oil on canvas. $55\frac{1}{4} \times 53\frac{1}{8}$ in (140·4 × 135·2cm)

In *Moonlight* Munch repeated some of the images and themes that had entered his repertoire over the past year. The erect frontal stance of the woman follows from the similar pose in *The Voice*. The arms again appear to be behind her back but there is less tension in the body. There is a suggestion that this is a scene of adultery rather than lost virginity. Perhaps he was thinking of his affair with Fru Heiberg when he came to paint this work.

Oslo, National Gallery

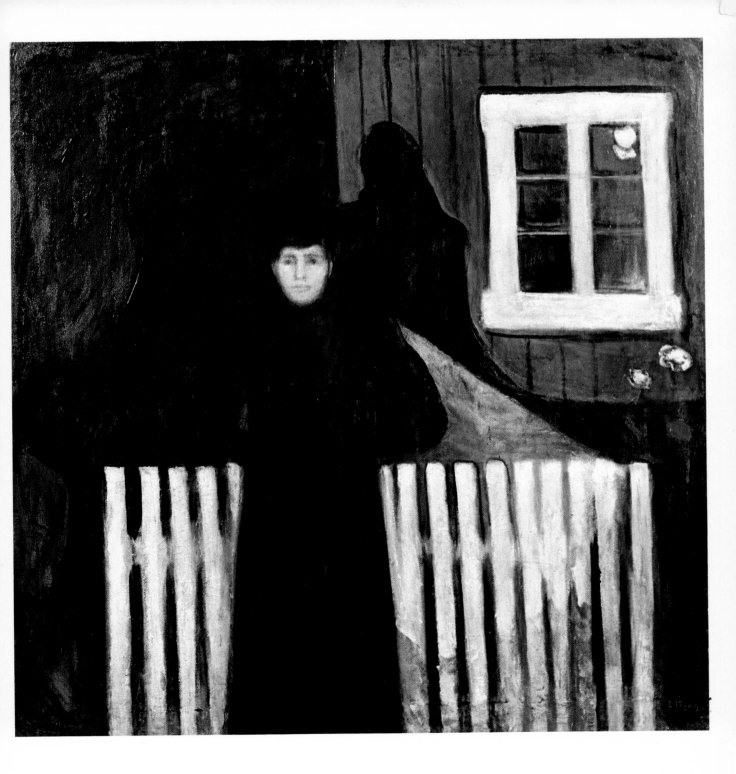

20. *Starry Night*

c.1893. Oil on canvas. $53\frac{3}{8} \times 55\frac{1}{8}$in ($135\cdot2 \times 137\cdot4$cm)

Munch's *Starry Night* was painted four years after Van Gogh's painting of the same title, and although there is no stylistic connection between the two works, both were the products of artists steeped in the northern Romantic tradition. For Romantics of any period the night-time can provoke the most powerful and poetic sensations, and it serves as a ready metaphor of the mystery and wonder of the universe. Munch's painting lacks the fiery spirals of Van Gogh's famous work, but the hulking group of lime trees and unexplained shadows has a mysterious and poetic strength.

Oslo, Munch Museum

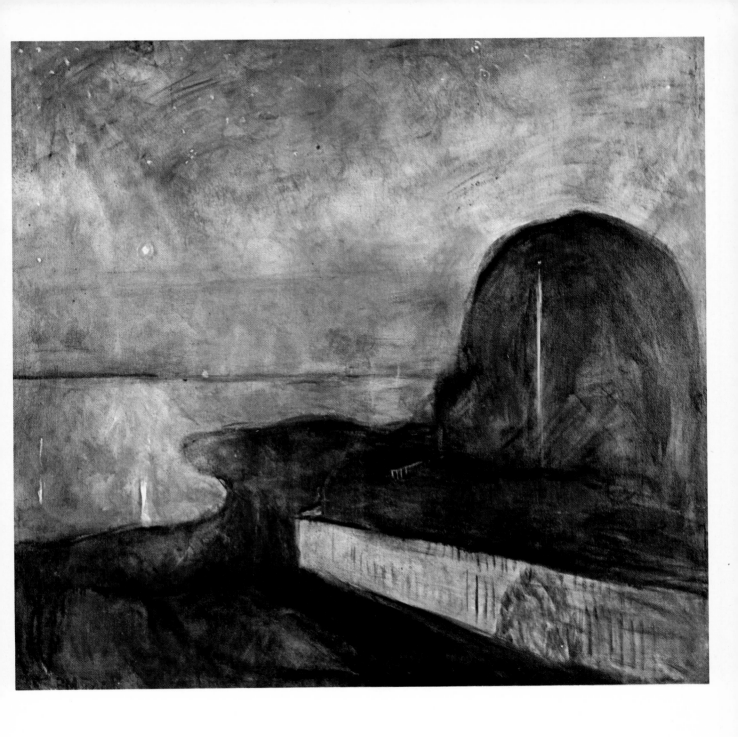

21. *The Scream*

*1893. Oil, pastel and casein on cardboard. 35¾ × 29in
(91 × 73·7cm)*

The Scream is Munch's most famous work. It is the
painting which most clearly demonstrates his contribution
to Post-Impressionist painting at the close of the
nineteenth century and it stands as a forerunner of the art
of the Expressionists two decades later. The combination of
strong colouring, swirling rhythms, and a dramatic use of
perspective, together with the despairing figure with his
hands clasped to his ears (a vain effort to shut out the
scream of nature), has produced a work of great
psychological and iconographic intensity. Truly, as Munch
himself scrawled across one version of this painting, only a
madman was capable of producing such a work.

But it is important to note that *The Scream* was not just
a work of pure imagination, but also the pictorial
rendering of an experience. In notes and diary entries
Munch recorded a scene which took place in Norway
while walking along a road bordering the Oslo fjord in the
company of two friends. A dramatic sunset brought on a
feeling of intense anxiety followed by physical exhaustion.
'I stood there trembling with fright,' he wrote, 'and I felt a
loud, unending scream piercing nature.'

Oslo, National Gallery

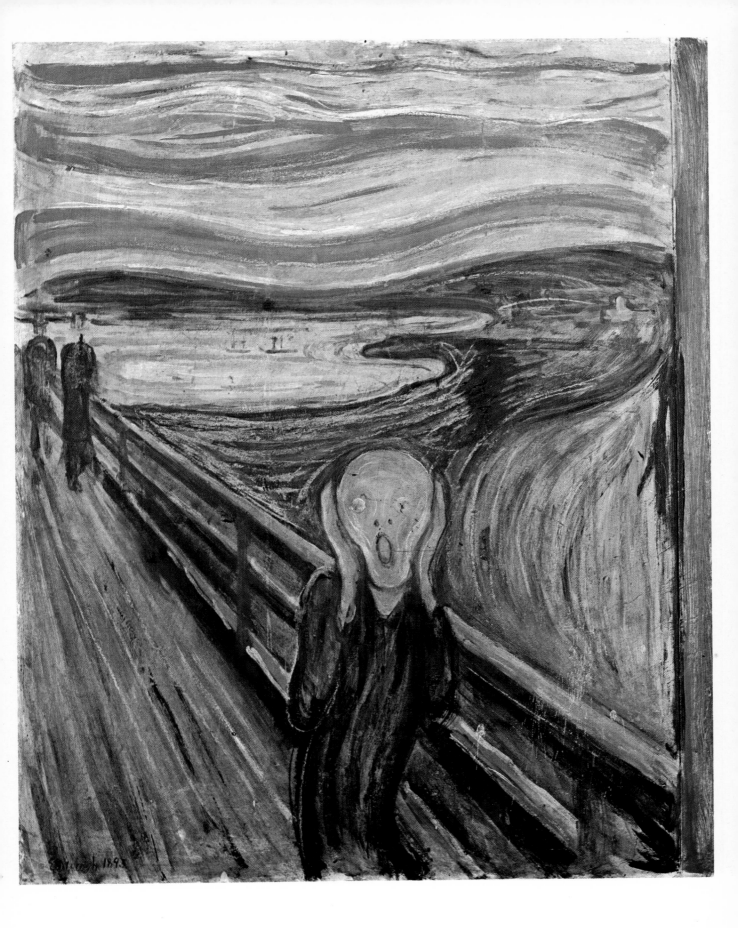

22. Anxiety

1894. Oil on canvas. $36\frac{5}{8} \times 28\frac{3}{8}$in ($93 \cdot 0 \times 72 \cdot 1$cm)

Once a motif or an image entered into Munch's consciousness he would often repeat and refine it in subsequent paintings and, later on in his career, in prints as well. Anxiety is a variation on the theme of *The Scream*, having the same blood-red sunset and sea inlet with boats, and also on that of *Evening on Karl Johan Street*, which has a similar marching, wide-eyed crowd, dressed as if they were on their way to a funeral.

Oslo, Munch Museum

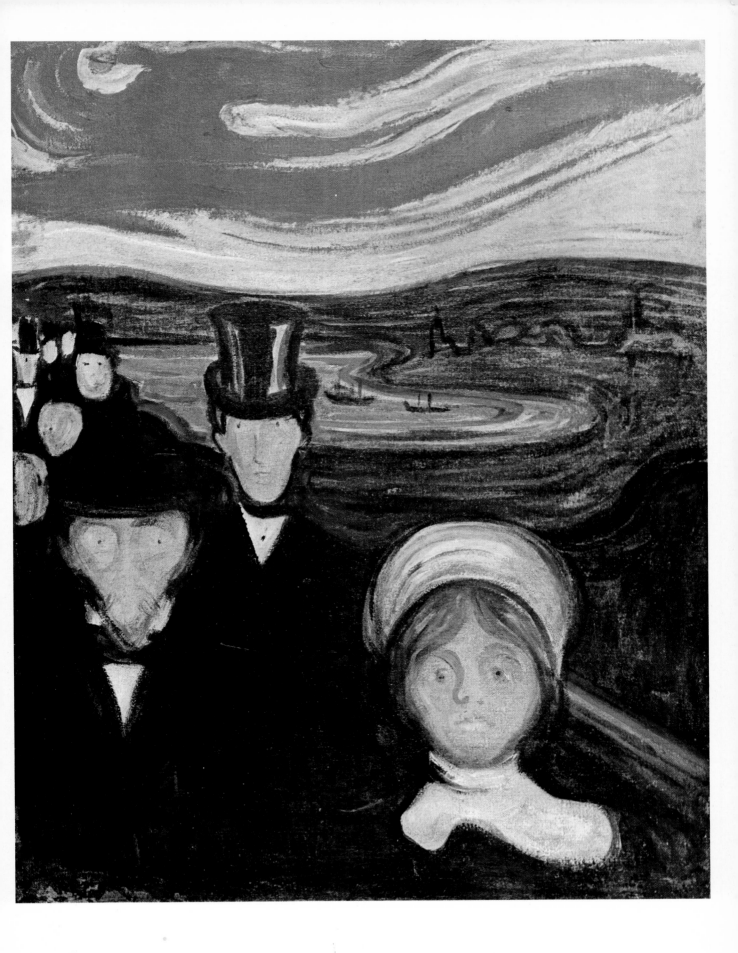

23. *Vampire*

1893. Oil on canvas. $31\frac{1}{2} \times 39\frac{3}{8}$in (80 × 100cm)

The title for this painting was given by Munch's friend, the poet Przybyszewski, but the artist had intended to suggest ideas not quite so literary. It was meant to convey the debilitating effect of a woman's love for man. Her embrace is meant to signify comfort rather than blood-sucking, vampirism. The man lies bent with pain, seeking solace by returning to the breast of his seductress and mother. Her flowing red hair, enveloping the head of the man present, is seen as threatening.

Oslo, Munch Museum

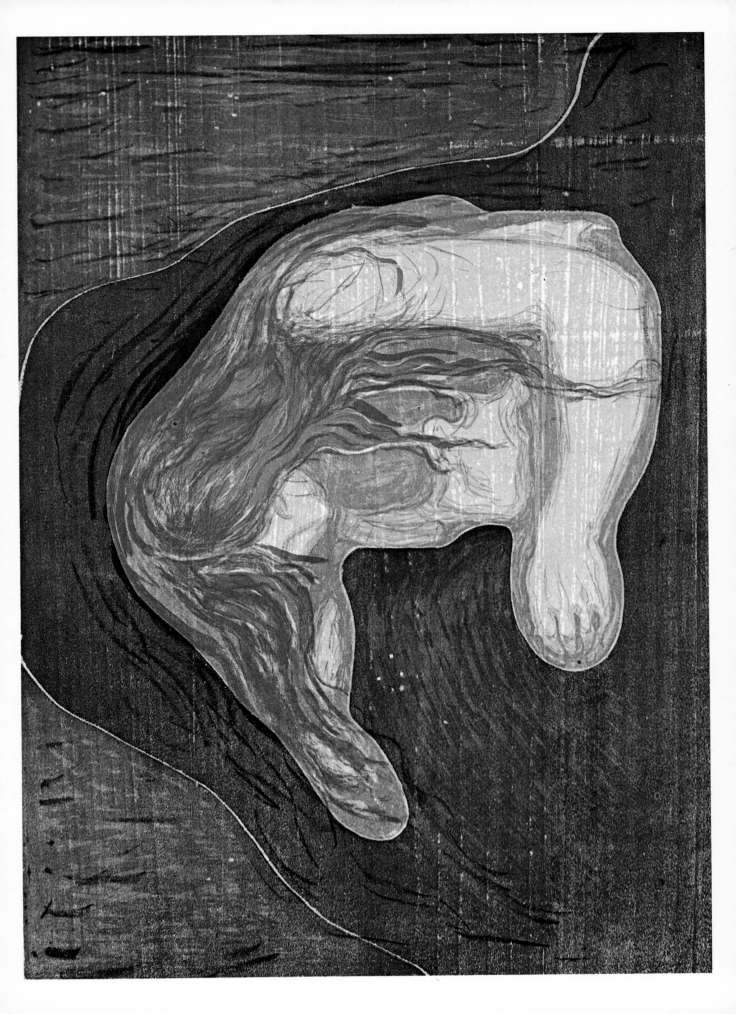

24. *Death and the Maiden*

c.1893. Oil on canvas. $50\frac{3}{8} \times 33\frac{7}{8}$ in ($128 \times 86cm$)

In *Death and the Maiden*, it is not the skeletal image of death which is the aggressor, but the young woman who actively embraces the feeble bones of Death. She is seeking the consummation of her desires, so that new life, symbolized by sperm and embryos, can take form.

Oslo, Munch Museum

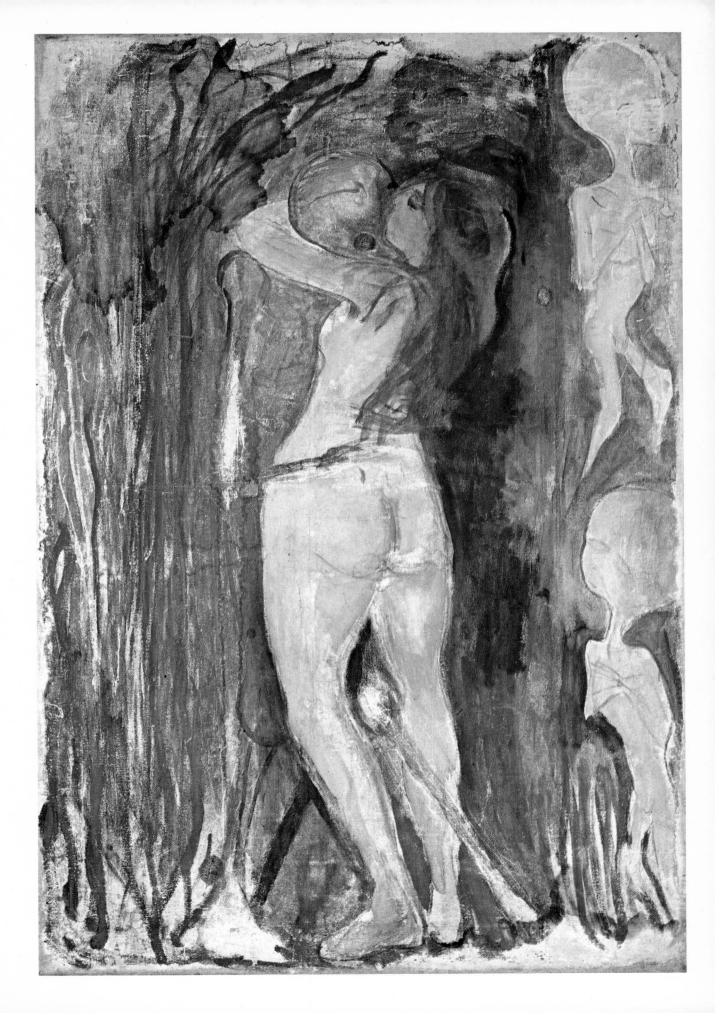

25. *Rose and Amelie*

1894. Oil on canvas. $30\frac{3}{4} \times 42\frac{2}{8}$in (78 × 109cm)

Since the days he spent drinking with the Christiania Bohemians, Munch had liked to paint café scenes. When he moved to Paris this tendency was reinforced by contact with French artists, a number of whom (notably Degas, Seurat and Toulouse-Lautrec) were interested in depicting the demi-monde. This picture was shown at the Salon des Indépendants and, no doubt, Munch hoped that it would appeal to his French audience. However, his exhibition made little impact, despite Strindberg's strident article in *La Revue Blanche* about it.

Oslo, Munch Museum

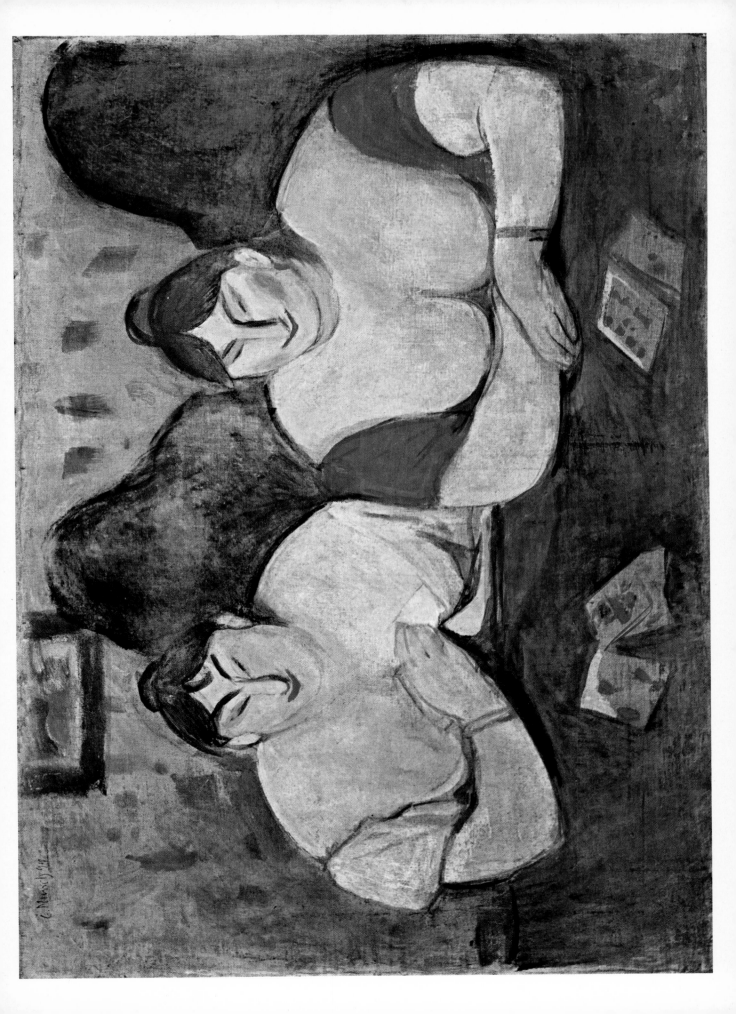

26. *Dagny Juell Przybyszewski*

1893. Oil on canvas. 59 × 44⅛in (158 × 112·1cm)

Dagny Juell Przybyszewski was one of those inhabitants of
Bohemia who achieve little themselves but gain
immortality in the writings and paintings of those they
come to know and love. According to the critic and
biographer Julius Meier-Graefe she had 'the lines of a
thirteenth century Madonna, a smile that drove men to
distraction, and she could drink absinth by the litre
without getting drunk'. She liked to dance with Munch or
Strindberg while her husband played the piano. Some time
later she became involved with a barbaric Russian, 'who
held a revolver to her forehead, and as she continued to
laugh, deliberately pulled the trigger, shooting first her
and then himself.'

Oslo, Munch Museum

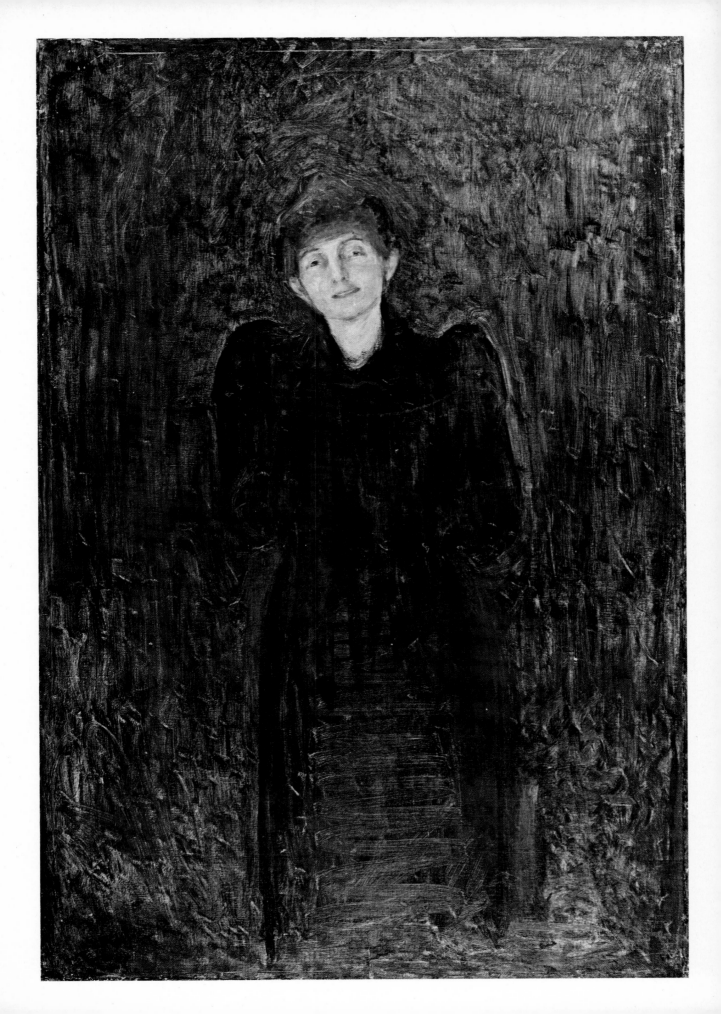

27. Jealousy

c.1895. Oil on canvas. $26\frac{1}{4} \times 39\frac{1}{2}$in ($66\cdot7 \times 100\cdot3$cm)

Dagny Juell's husband at the time when Munch knew her
was the poet Stanislaw Przybyszewski, seen in this
painting with white face and red beard staring out of the
canvas. Dagny is cast in the role of temptress and Eve,
dressed in adulterous red, as one arm rises to pick the
forbidden apple and the other is kept behind her back.

Bergen, Collection Rasmus Meyers

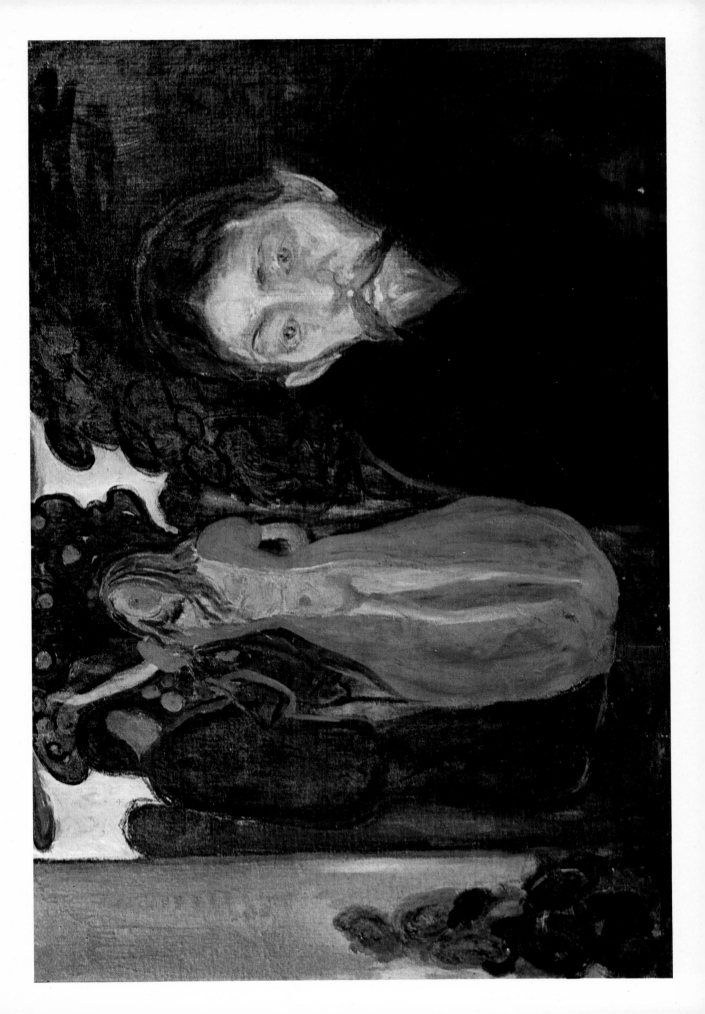

28. *The Red Vine*

1898. Oil on canvas. 47 × 47⅝in (119·4 × 121cm)

In *The Red Vine* Munch moved on from the rather literary imagery of *Jealousy* to produce a work in which emotion is conveyed through more painterly means. He replaced the adultress figure of Eve with a house covered by a red vine. The wicker-fence in *Moonlight* reappears, and there is again the receding perspective caught by the pathway which links the head and shoulders of the man (Przybyszewski again) to the house in the background.

Oslo, Munch Museum

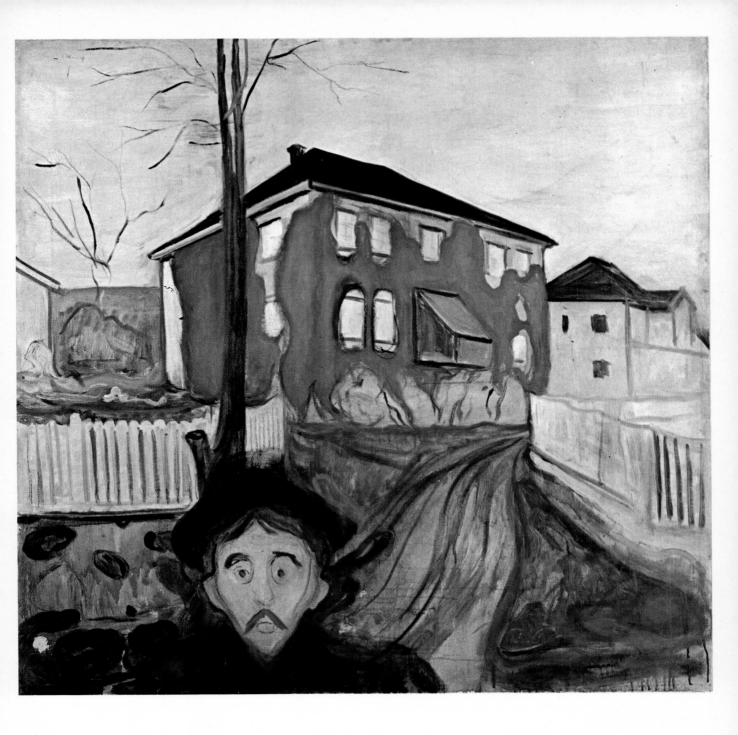

29. *Self-Portrait*

1895. Oil on canvas. 43½ × 33⅝ in (110·5 × 85·4cm)

At thirty-two, when this portrait was done, Munch was at the height of his powers. He had by then completed some of his finest and most expressive canvases, and after years of struggle, critical and financial success lay before him. In this portrait he stands erect but his expression is tense as if haunted by emotional problems for which there seems no solution. The source of illumination which is in front and below him was intended to suggest the flames of hell.

Oslo, National Gallery

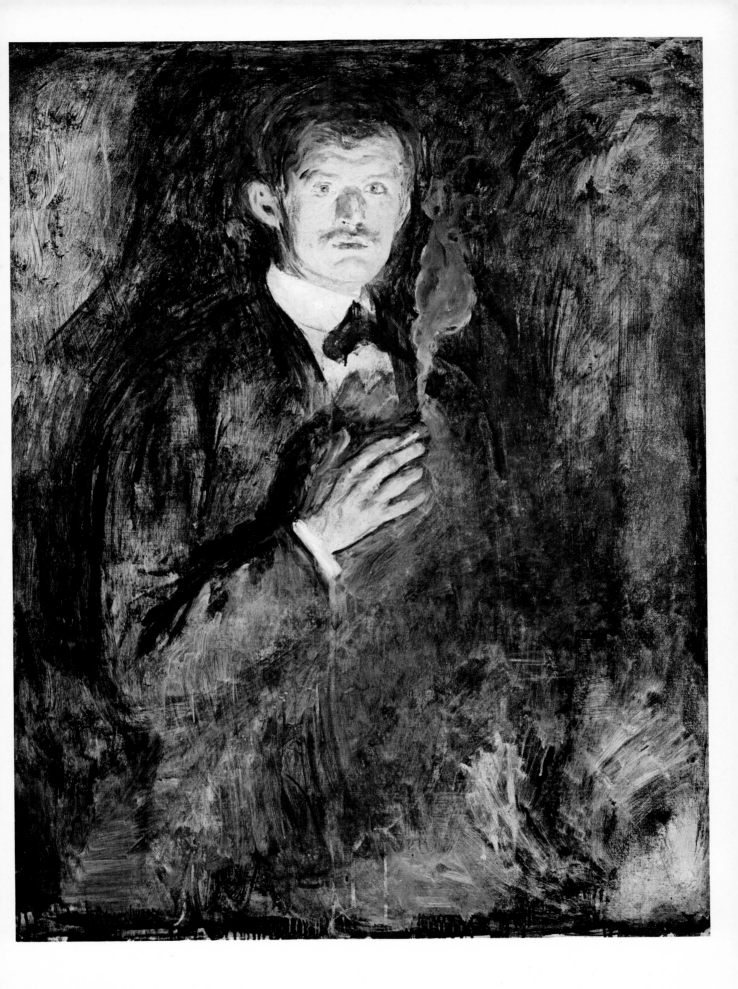

30. *The Dance of Life*

1899–1900. Oil on canvas. 49½ × 75in (125·7 × 190·6cm)

Munch had a cyclic view of life. 'We repeat ourselves like
crystals that are dissolved and then recrystallize again,' he
once explained. At the centre of this cycle was not God,
nor man, but woman, seen in this painting fulfilling her
biological role, as she first becomes conscious of sex,
dressed in white, while spring flowers bloom at her side:
then consummates her passion in a flaming red dress as
she dances somewhat rigidly with man: and finally dressed
in black, she stands as a spent force, awaiting death. The
demonic dancing couples in the background, in the black
and white, reveal other stages of desire. The dance takes
place, as in so many of his works about sexual attraction,
on the shore. Once again there is the familiar sight of a
sun (or moon) throwing a pale light across the water.

Oslo, National Gallery

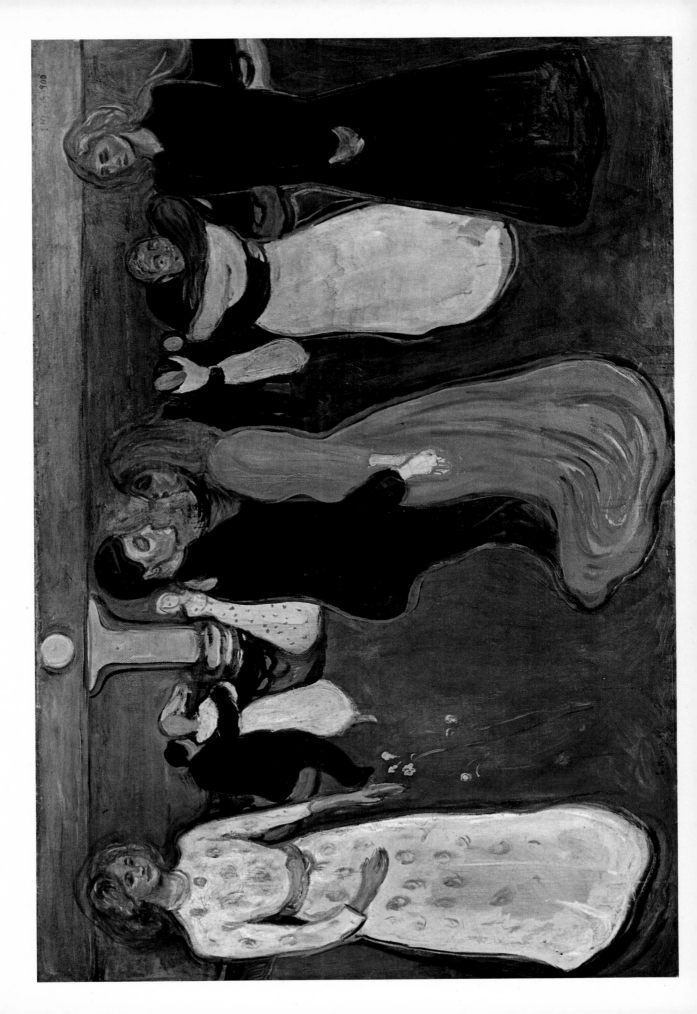

31. *Girls on the Jetty*

c.1899. Oil on canvas. $53\frac{1}{2} \times 49\frac{3}{4}$in ($134{\cdot}8 \times 126{\cdot}4$cm)

Girls on the Jetty is one of Munch's most popular and widely reproduced paintings. It is a more harmonious painting than *The Scream* and less overtly emotional. The pronounced diagonal of the jetty is a familiar Munchean device and there is a suggestion of something mysterious and all powerful lying beyond the confines of the jetty which attracts the attention of the day-dreaming girls.

Oslo, National Gallery

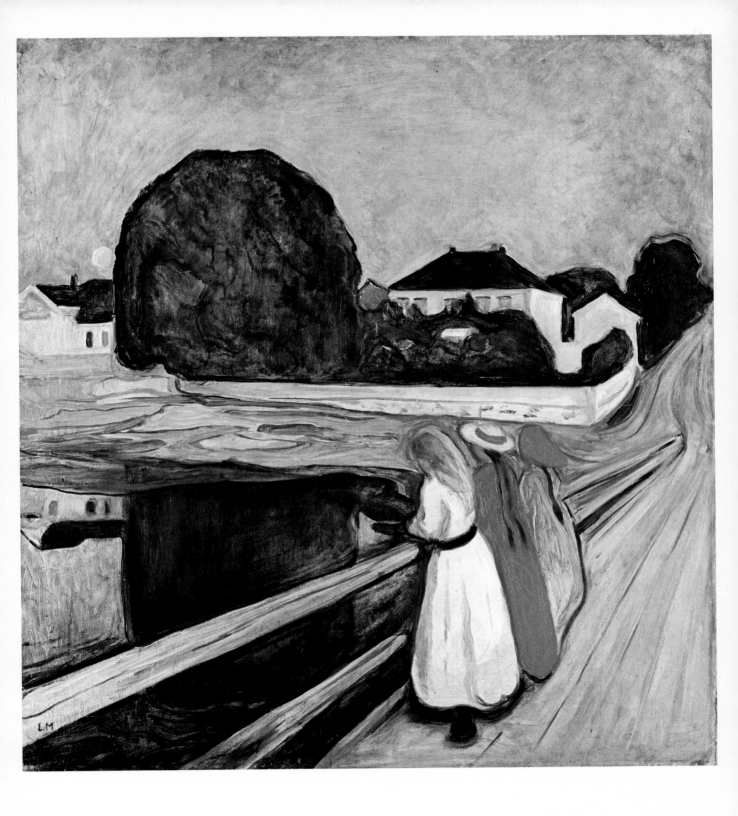

32. *The Sick Child*

1896. Coloured lithograph. $16\frac{1}{2} \times 22\frac{1}{4}in$ (41·9 × 56·5cm)

After 1895 Munch became more and more involved with producing prints. He learnt colour lithography from the master printer Auguste Clot in Paris, who had helped produce Bonnard's and Toulouse-Lautrec's best prints. The medium allowed Munch to restate some of the images which most obsessed him. Often these have greater effect than the original paintings. This version of *The Sick Child* is one of his finest and most successful lithographs.

Oslo, Munch Museum

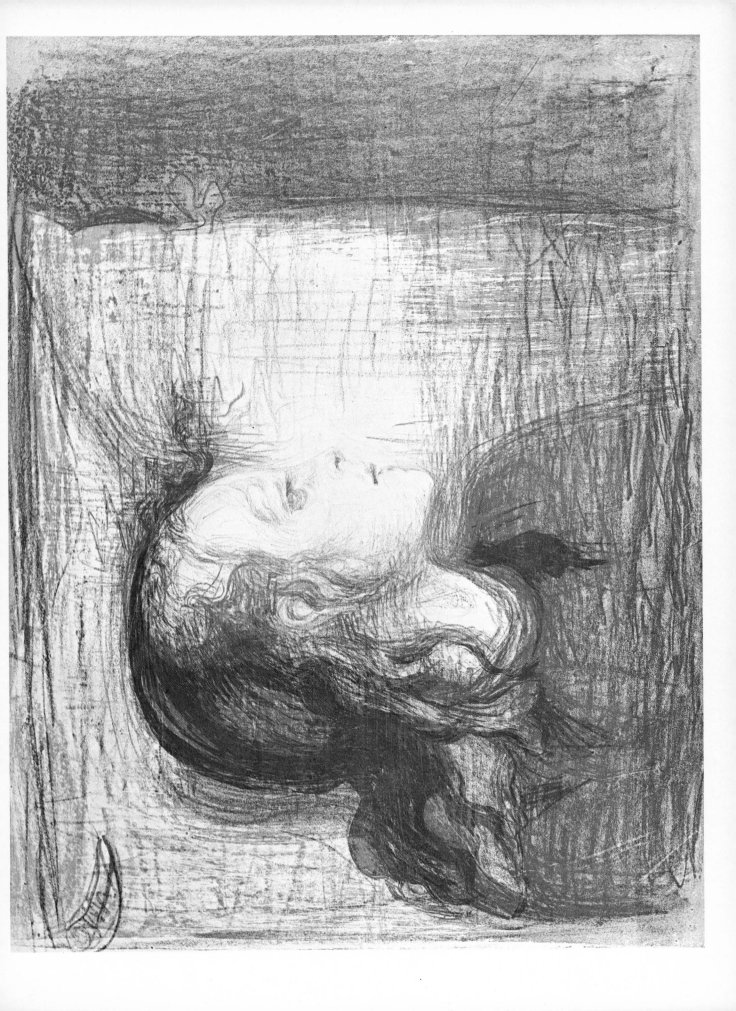

33. Sin (Nude with Red Hair)

1901. Coloured lithograph. 19½ × 15¾in (49·5 × 39·9cm)

In lithography Munch showed a lightness of touch which he did not often achieve in his oil paintings. This is particularly true of those paintings of nude models done in later years in which the figures are apt to get drowned in paint and harsh colour. Like so many of Munch's temptresses, this figure boasts a mass of long flowing red hair.

Oslo, Munch Museum

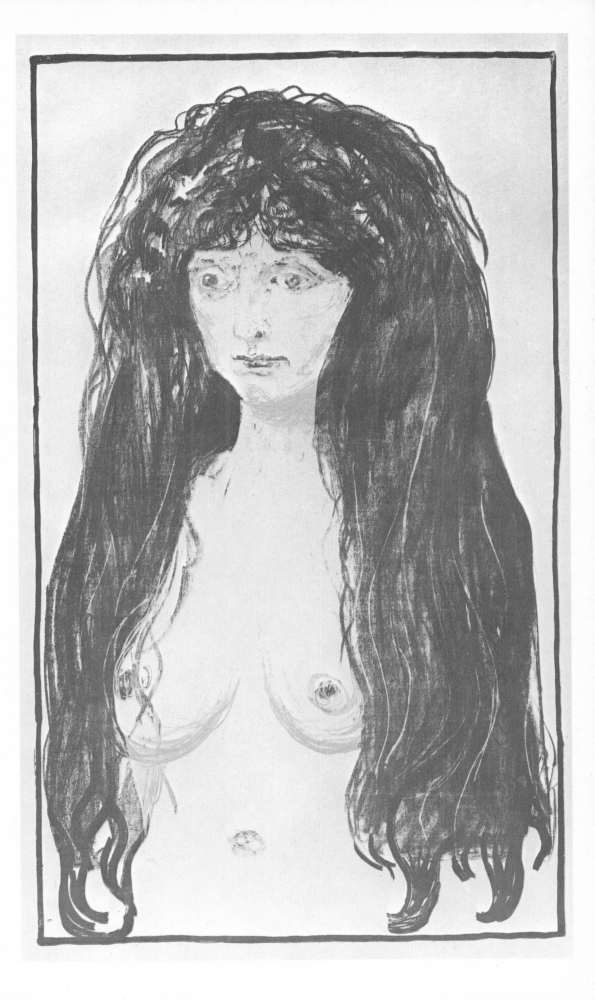

34. *The Lonely Ones*

1899. Coloured woodcut. $15\frac{1}{2} \times 20\frac{7}{8}$ in ($39\cdot5 \times 53$ cm)

With woodcuts Munch showed considerable ingenuity. He liked to make use of the grain in the wood to produce textural effects. He also developed a means of using different colours in the same print by cutting up the blocks. In *The Lonely Ones* he combined technical virtuosity with an archetypal Munch subject – a man and a woman on the seashore. The girl in virginal white is gazing out at the limitless sea, apparently unconscious of, or indifferent to, the man just beside her.

Oslo, Munch Museum

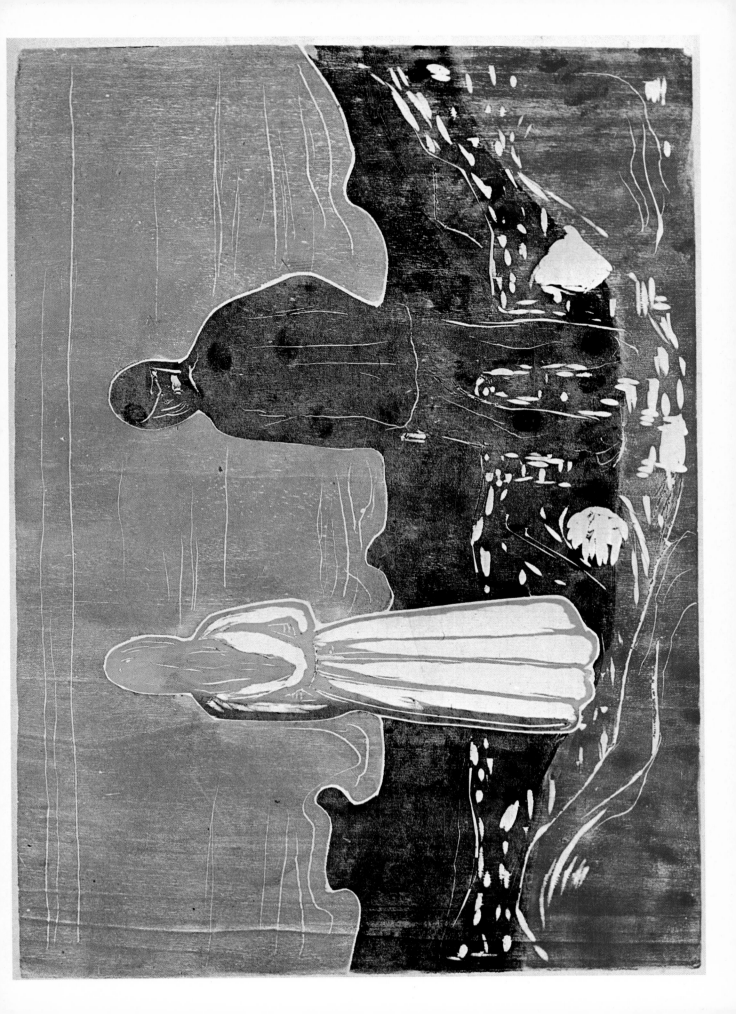

35. *Portrait of Dr Daniel Jacobson*

1909. Oil on canvas. $80\frac{1}{2} \times 43\frac{7}{8}$in (204·4 × 111·4cm)

Throughout his artistic career Munch proved himself to be the master of the full length portrait, using facial expression and body pose to convey the personality of his sitters. In this imposing portrait he captures the self-confident and domineering figure of Dr Jacobson, the doctor whose clinic Munch entered in 1908. 'I placed him large and with legs apart in the fire of all the colours of hell' Munch wrote. It was perhaps his way of obtaining revenge for the months of no-nonsense treatment he received at the hands of the doctor.

Oslo, Munch Museum

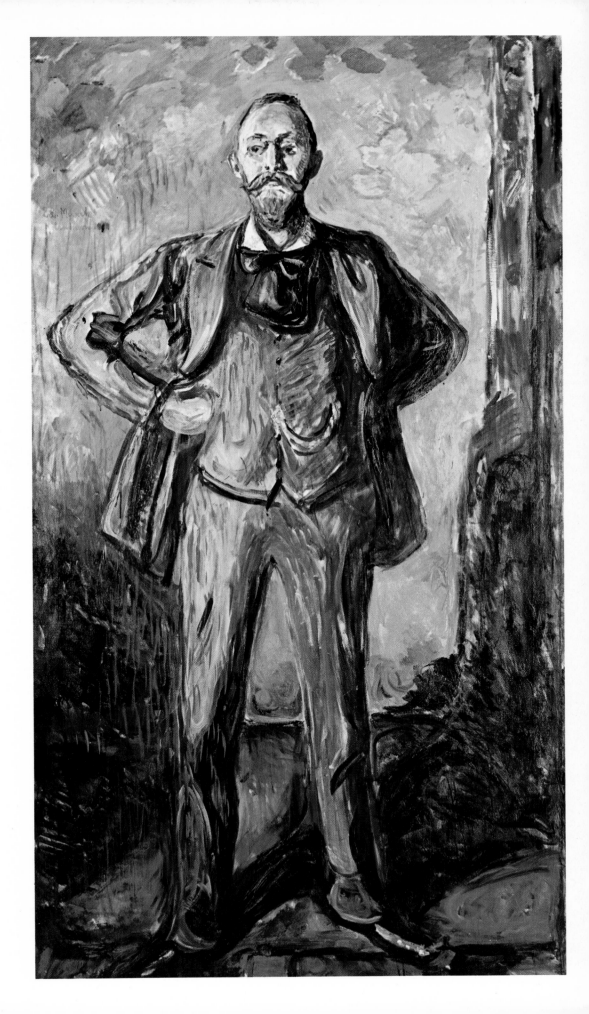

36. *Galloping Horse*

c.1912. Oil on canvas. $58\frac{1}{4} \times 47in$ (147·6 × 119·4cm)

After his release from Dr Jacobson's clinic and his return
to Norway, Munch turned for his subject matter away
from portrayal of the inner emotional state of man to
subjects drawn from the external world. The galloping
horse pulling a sleigh along a Norwegian lane, which
seems dangerously out of control, presents an external
physical threat, not an inner psychological one.

Oslo, Munch Museum

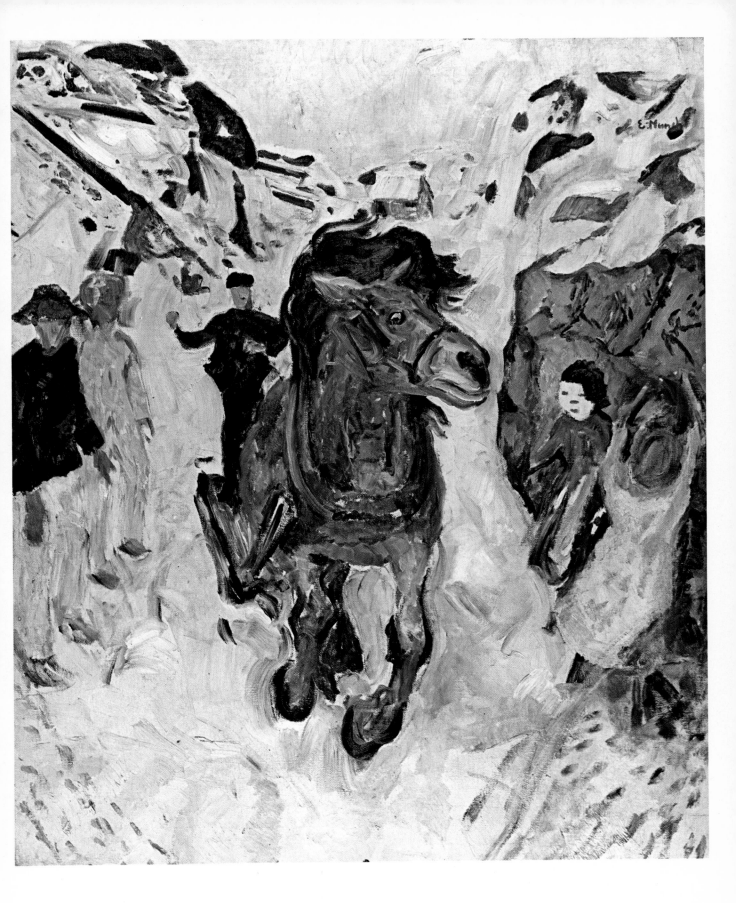

37. *Youth and Ducks*

Started 1905. Oil on canvas. $39\frac{1}{2} \times 41\frac{3}{8}$in (100·3 × 105·1cm)

Munch completed this painting, which he had begun in
Germany, after his return to Norway in 1910. Like the
Galloping Horse the danger in this painting is an external
one, shown here by a group of village boys throwing
stones at some ducks while their sisters appear to cower
under a tree.

Oslo, Munch Museum

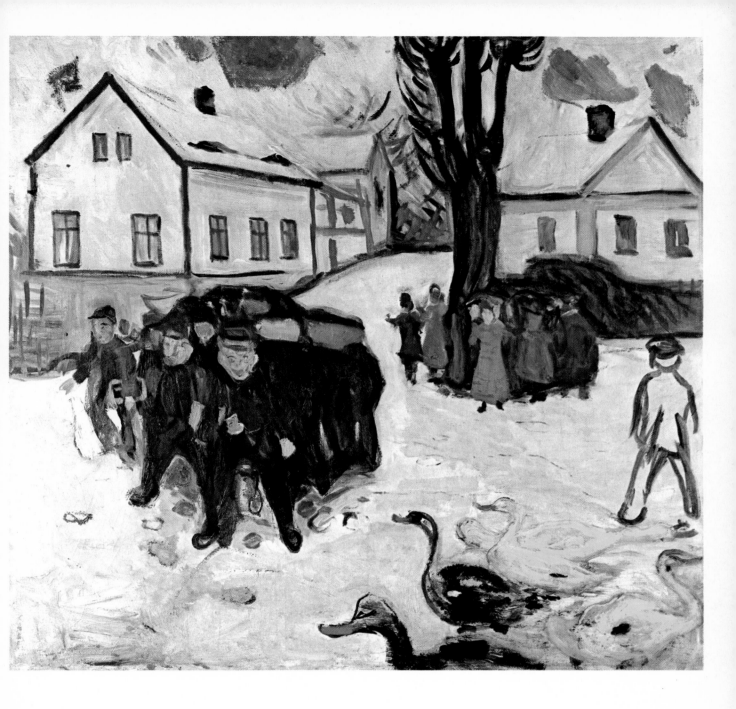

38. *Workmen on their way home*

1915. Oil on canvas. 79½ × 89½in (202 × 227·3cm)

Munch was first attracted to the theme of workers by the sight of snow shovellers. He was convinced that the time of the worker had come and he hoped to execute a series of murals on the theme of the worker after completing his murals for the university. The scheme was never realised but this large and dramatic canvas was one of the indirect results. Its composition recalls that of *Evening on Karl Johan Street (plate 16)*, but the figures in this canvas convey a sense of hulking aggressive strength in a marked contrast to the ghost-like faces of the Christiania bourgeoisie in the earlier work.

Oslo, Munch Museum

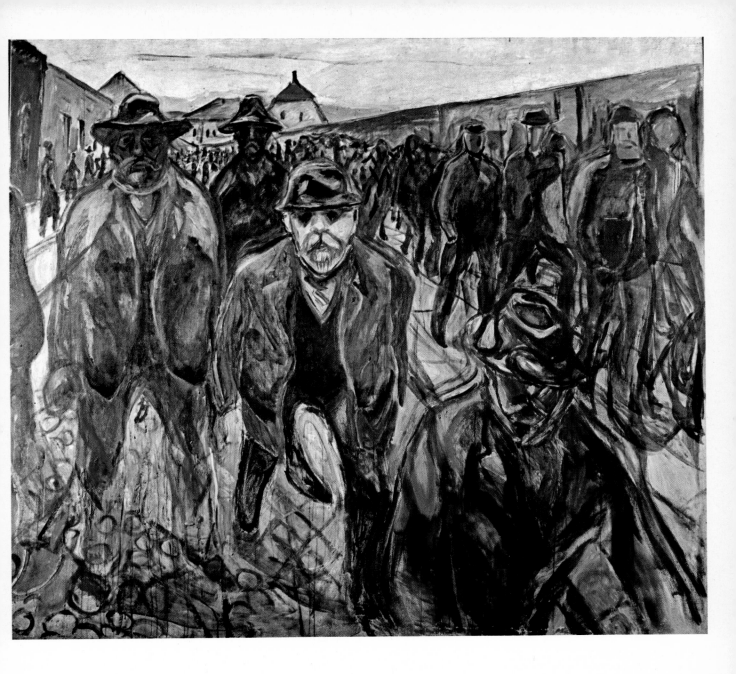

39. *The Fight*

1934. Oil on canvas. $41\frac{3}{8} \times 47\frac{1}{4}$in ($105 \times 120$cm)

This painting recalls Munch's fight with the painter Ludvig Karsten. In the years leading up to his breakdown Munch was acutely suspicious of many of his associates, even his friends, suspecting dire plots against him. As a tall man, with a strong physique, he was able to inflict severe damage on anyone unlucky enough to cross his path.

Oslo, Munch Museum

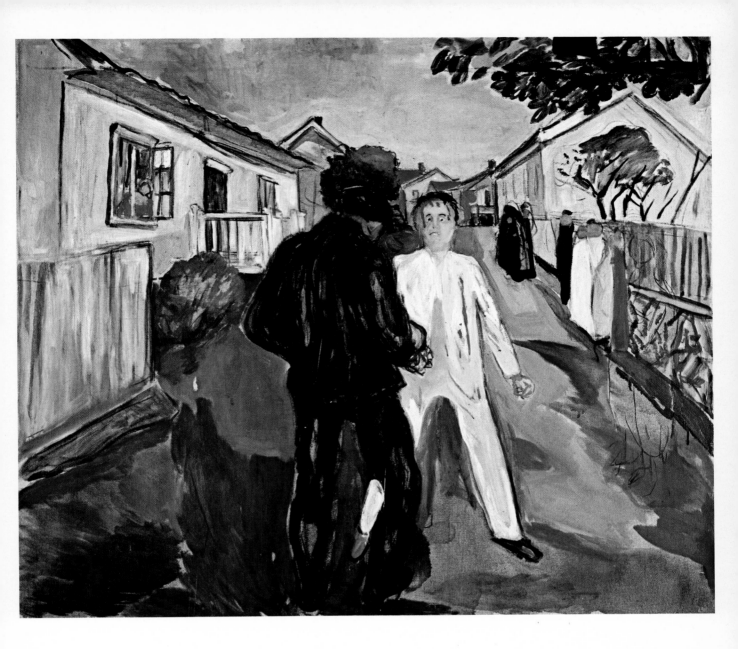

40. *Self-Portrait, Between Clock and Bed*

1940–2. Oil on canvas. $58\frac{3}{4} \times 47\frac{1}{2}$in (151·8 × 120·7cm)

There is a suggestion of Bonnard in this late self-portrait, done when he was seventy-seven. It depicts the artist poised between time (represented by a faceless clock) and his last resting place, his bed. In the background are stacked his hope for survival – his canvases.

Oslo, Munch Museum

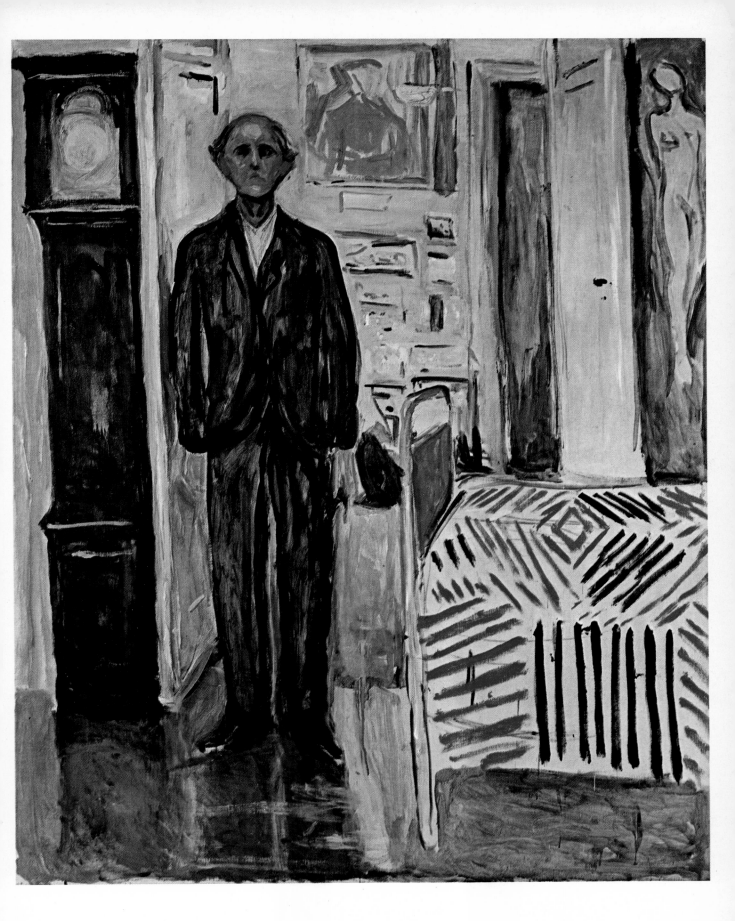

IAN DUNLOP AND BLACKER CALMANN COOPER LIMITED
would like to thank all owners, especially the Oslo Kommunes
Kunstsamlinger and the National Gallery, Oslo, for allowing
works in their collections to be reproduced. Plate 17 is
reproduced by permission of the Museum of Fine Arts, Boston
(Ernest Wadsworth Longfellow Fund). They are grateful to
those who have provided transparencies, in particular the
Munch Museum and Fotograf O. Vaering, Oslo.